Arthur Rackham
Masterpieces of Art

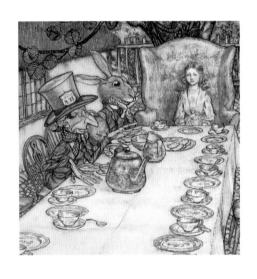

Publisher and Creative Director: Nick Wells
Assistant Editor and Picture Research: Josie Mitchell
Art Director and Layout Design: Mike Spender
Copy Editor: Karen Fitzpatrick
Proofreaders: Josie Mitchell and Laura Bulbeck

Special thanks to: Laura Bulbeck and Helen Snaith

FLAME TREE PUBLISHING

6 Melbray Mews,
Fulham, London SW6 3NS
United Kingdom

www.flametreepublishing.com

First published 2015

15 17 19 18 16
1 3 5 7 9 10 8 6 4 2

All images by Arthur Rackham (1867–1939). Original publications are listed below each image except for
those in the introductory section, "Arthur Rackham: Clerk, Artist, Goblin Master": Lewis Carroll, *Alice's
Adventures in Wonderland*, William Heinemann, London, 1907: 6(b), 9(t, b), 12, 18(t), 20(t), 23(b); Charles
Dickens, *A Christmas Carol*, William Heinemann, London, 1915: 7(b), 14(t), 15, 18(b); *The Nursery
Rhymes of Mother Goose*, William Heinemann, London, 1913: 7(t), 13(b), 14(b), 16(b), 17(t, b), 19(t) 22(t,
b), 24(t); John Milton, *Comus*, William Heinemann, London, 1921: 16(t), 26(t, b); V. S. Vernon, *Aesop's
Fables*, Doubleday, Page & Co., New York, 1912: 10(t), 11(c); Eden Phillpotts, *A Dish of Apples*, Hodder
and Stoughton, London, 1921: 6(t), 8, 10–11(b), 25 (t); William Shakespeare, *A Midsummer Night's
Dream*, William Heinemann, London, 1908: 25(b), 27(t); Nathaniel Hawthorne, *A Wonder Book*, Hodder
and Stoughton, London, 1922: 9(r), 20(b), 21, 24(b).

ISBN 978-1-78361-362-5

Printed in China

Arthur Rackham
Masterpieces of Art

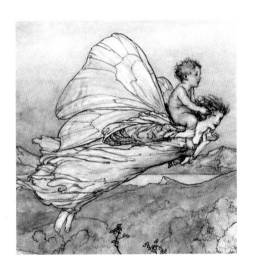

Joseph Simas

FLAME TREE
PUBLISHING

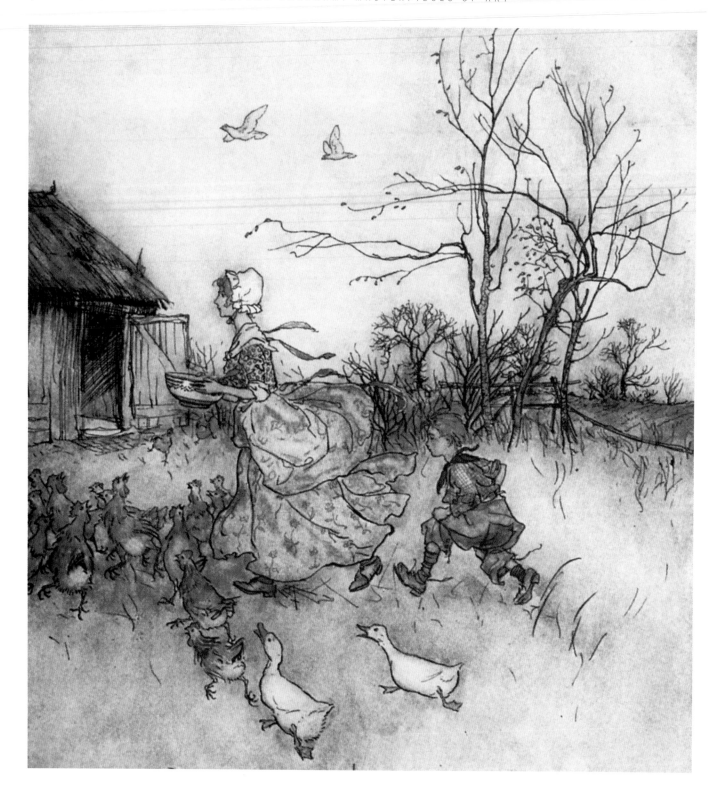

Contents

Arthur Rackham: Clerk, Artist, Goblin Master

'The Goblin Master', English artist Arthur Rackham (1867–1939), is as hard to define as a man as he is an artist, though there is little to indicate that he intended to dissimulate neither anything in his person or in his art. Still, behind the man and his numerous images there is always more than meets the eye.

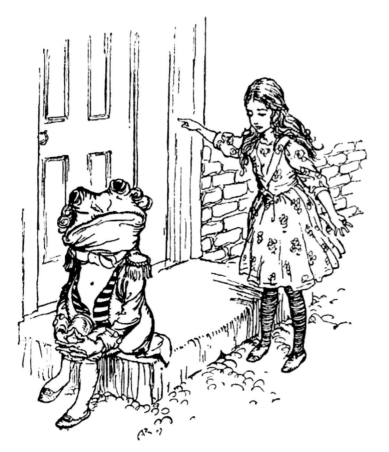

A rare bookseller wrote recently:

'[He is best known for his …] handsome russet quarto lettered gilt and with 50 colour plates – illustrations that made Arthur Rackham famous and turned his illustrated books into a publishing phenomenon. Tens of thousands of his books were sold over the next 30 years from Poe to Swinburne, Hans Andersen to Shakespeare. It used to be said that a dealer with a big enough check book could fill a pantechnicon full of Rackham just going round the shops of Southern England.'

Early Life

Arthur's father, Alfred Rackham (1829–1912), the product of school-masters and the sole surviving child of his parents, became a clerk at the age of 14. He rose quickly through the ranks at Doctors' Commons and after the Crimean War with Russia in 1854 Alfred became a highly ranked, well-paid, and securely employed civil servant with a full clerkship.

At the age of 32, in 1861, Alfred married a pious and religious Baptist woman who he had met ten years earlier, Annie Stevenson (1833–1920). Her parents were successful lace manufacturers and retailers from a line of schoolmasters and Baptist ministers.

In 1862, Annie had her first child, a boy Alfred, followed by another boy Percy, in 1864. Alfred died of meningitis in Percy's first year. Percy was an epileptic whose left arm was paralyzed. A girl, Margaret, was born in 1866; Arthur, the main subject of this book, in 1867; and Harris, in 1868 – all three were healthy.

Alfred's mother and father lived with the family on South Lambeth Road in London. Two other children were born and died in 1871 and 1872 respectively. Percy was sent to live with a clergyman in 1873 which was the same year that his sister Winifred was born. Another sister Mabel (1875–76) was born and then in 1876, 1877 and 1879, three healthy brothers, Bernard, Stanley and Maurice were born. The house in 1873 (before Mabel) was comprised of four adults (parents and paternal grandparents), four children, and three servants and nursemaids.

Arthur's paternal grandmother died in late 1873 followed by his grandfather six months later in 1874. At the impressionable age of 12 Arthur Rackham had already intimately experienced more family birth, illness, struggle, sorrow, life and death in such a short time than most people see, then as now, in a lifetime.

The reasons for this rather stark depiction of Arthur's early years will become apparent, I believe, throughout this look into his life and art.

Sorrows and Joys

Despite what many might consider an upbringing full of tragic events, and early childhood death being more common in the late nineteenth century than it is today, there was no lack of joy, mischief, study, humour and affection around the Rackham house. It is clear that his father and mother Alfred and Annie, despite their sorrows, were often joyful, loving and caring for all.

Among the many memories to be found in Arthur's scattered correspondence, one stands out even more clearly than his anecdotes about his family and friends: for as long as Arthur can remember he had a pencil and paper at hand, even when it was time to be fast asleep in bed. The father, Alfred Rackham left the Church of England

to become a Unitarian in 1853. Generally Christian, and monotheist, Unitarians reject the doctrine of the Trinity, have no established creed, are tolerant of other religious views, and believe strongly in individual freedom and the use of reason in religious matters.

In *Arthur Rackham, A Life With Illustration*, by James Hamilton (Pavilion, 2010), a fascinating and thorough biography of Rackham, Hamilton writes, 'That Alfred [could maintain] so rigorous a balance in his private and professional lives between a progressive social responsibility and a loyalty to an established system, speaks volumes for his energy, intelligence, pragmatism and tact.'

The Bookish Cleric and Artist

This summarized view of the Victorian life of young Arthur and his family, evokes the reality of what it once meant to be a 'clerk', and avoids from the start labelling Arthur Rackham as merely an illustrator, a children's book illustrator, or a draughtsman of personified trees, elves, fairies, odd anachronistic characters and other epithets that have been bestowed upon him since his rise to fame at the beginning of the twentieth century. I do not intend or wish to demean his talents in this realm, nor, especially, to make light of the kingdom he himself, with a few others, constructed; this era has come to be known as the Golden Age of Illustration (more on this later). Arthur Rackham is much more than a renowned illustrator, which is already no mean task. Simply put, calling him an artist (the role preferred to the illustrator by the Getty Museum, for example) raises issues that

began to arise during the modernist (then, later, the post-modernist) period that Rackham for the most part publicly ignored or criticized. By modernist circles he was snubbed in kind. It is beyond the scope of this study to argue on his behalf as a modern artist, but some of the circumstances that led him to be an illustrator-artist and many of the choices he made throughout his long and industrious career can perhaps shed light on some of the mysteries of the man – as well as, perhaps more importantly, on the refined qualities of his drawings, landscapes, paintings and, of course, illustrations. This study may also lead some to consider what distinguishes artists from illustrators, especially in the twentieth century, and why today the lines have become increasingly blurred between what can be summarized as 'high' and 'low' art.

In any case, Rackham, from the moment he got out of school, started to make a living as an illustrator for hire. He followed the traditional route from illustrations and marginalia for magazines and books. What distinguishes him from other illustrators is his early beginnings as a watercolourist, both for illustrations but also for paintings of nature. His few forays into oil painting and portraiture in oil differ in subject from what we best know him for: a painter of the imagination, of fantasy, faeries – enchanted lands of fairies, elves and fantastical creatures.

Schools of Study, Practice, Travel and Work

In 1879 Arthur entered the City of London School, a day public school, and proved to be a popular and happy student, though not especially an academic one. He was studious, however, and met his first drawing master, a talented teacher who led him to win the school's prize for Memory Drawing in 1883. The following year, Arthur also won the school prize for drawing. Any questions of Arthur's general intelligence (as opposed to academic compliance) were settled when in the fourth form Arthur won the prize for Proficiency in Algebra and Trigonometry. For Arthur, whatever the case, it was clear that he was destined to become an artist.

Unspecified health problems, however, dogged him. Given the family's history of illness and premature death, the Rackham physician, a renowned physician of the day, suggested a sea voyage, in this case, to Australia. He was to travel there in the company of two ladies, family friends, who were emigrating there. Neither the family nor Arthur voiced any objections.

Sick Leave at Sea Towards the Down Under

Arthur Rackham was not a child prodigy. His sociable nature warmed him to people who he caricatured with gentle wit. Without saying he worked hard – for that would imply a belaboured quality about him and his work that he never appeared to display – he was drawing all of the time.

On the ship over to Australia he easily fit into the company of the second-class passengers, a couple of whom were also on the voyage for reasons of health. He drew sketches and caricatures of the passengers, sometimes bestowing names on them: 'Fool, Gin and Bitters', 'Tasmanian Devil', 'Jumbo', 'Wooly', and so on. At the close of each day he measured the distance covered and at the end of the 48-day trip calculated its average speed (approximately 10.5 mph). Upon arrival he stayed in Sydney for nearly

three months and painted watercolours of the harbours, the bays and other sights.

As an older man, he was asked to write a piece entitled 'In Praise of Water Colour' and reminisced about receiving his first set of paints and brushes. It seems his pencil was for ever in one hand and his shilling paint box in the other. In that essay he wrote, ' … from that day when I first put my water-colour brush in my mouth, and I was told I mustn't, this craft we are celebrating has been my constant companion.'

It was on that trip to Australia that Arthur began to show mastery of a medium that he would continue with and improve upon his whole life. He became especially adept at combining watercolours with pen and ink drawings to create images that were perfectly adapted to new and emerging printing techniques and paper used to publish books. While the teenager's pictures may not all have been highly skilled, they showed great promise. Aside from his love for watercolour, it was clear early on that he had a gift for line drawing.

Entering the World of Art

Rackham passionately believed that illustration and painting were two separate fields, commenting that:

'A picture both in subject and treatment must be considered as a work for constant contemplation – a permanent companion. An illustration, on the other hand, is only looked at for a fraction of time, now and then, the page being turned next, perhaps, to a totally different subject, treated, it may even be, in a totally different way. In this branch, bizarre and unusual effects of arrangement, violent actions, exaggerations and other matters of spasmodic interest may find a place almost forbidden on the walls of a room.'

It is not my purpose or role to argue over the definitions of a master painter and illustrator. Nonetheless, the statement above can be seen as one reason why

modernists — from early twentieth-century painters to contemporary artists — have not invited Rackham into museums with open arms. Setting aside the questions of figurative painting, drawing and abstract art, I believe it is Rackham's phrase 'constant contemplation – a permanent companion' that is one part of what modernism (leading to deconstruction) tried to distance itself from, all the while, ironically, seeking that which was 'almost forbidden on the walls of a room.'

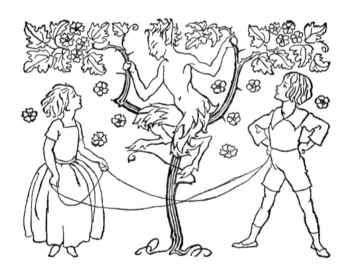

Illustration Or Painting?

Rackham's insistence of the differences between illustrations and paintings is one of the inherent qualities in his art that first lead me as a child to painters such as Giotto, Brueghel, Rembrandt, Mantegna, the Pre-Raphaelite Brotherhood, Klimt, Whistler, Blake and Homer. In short, painting as an art with (unexpected) meaning.

As an avid reader of the 'childhood' classics in the 1960s, Rackham's abrupt and jarring shifts of subject and sometimes even medium, while not shocking to a young boy of the age of television and movies, were perhaps the perfect way to enter the vast world of painting, which by today's curatorial standards and decisions are often displayed much more in accordance with the thought of someone like Rackham than, say, the old-school habit of grouping paintings by periods or schools. Of course, that remains the standard in today's academic

museums and major galleries, but the trend to exhibit disparate works and media in the same room (including works that are 'almost forbidden' which sounds rather quaint now) is the norm in most modern art museums.

Today, it is not unusual to find one of Rackham's works of art – drawing, watercolour or painting – on the walls of a room, manor, home, museum or other.

The Call of the Clerk

Despite his more than apparent filial and family closeness, it is rather obvious that Arthur did not want to follow in his father's footsteps and become a clerk. This is speculation, of course, for Arthur did pass the test to become clerk at the Westminster Fire Office. He would have known, no doubt, that this was the most obvious way to become self-sufficient financially, which was a fundamental part of his upbringing (and a relatively easy path given his father's career). But Arthur did not

receive a position immediately and had to bide his time at home. Once he did become a clerk a year later his compromise to attend the Lambeth School of Art evening classes showed his resolve to build a career in painting.

While there were a number of notable and skilled talents at the school, and Rackham's master was an accomplished landscape artist who had studied in Paris, William Llewellyn (1858–1941), clearly the Lambeth School was a choice based on pragmatism, if not on behalf of another's wishes. Whatever may be said for Rackham's particular case, everyone then as now knew that 'night school' led to many frustrated careers and failures in the very tough and competitive world of art (whether merely decorative or 'pure'). Today, of course, the business of fine art has also changed the way such decisions are made. Be that as it may, one will never know what would have become of Rackham had he been allowed or subsidized to study art full-time. It is, however, apparent that Rackham's pragmatism and diligence allowed him, basically on his own, to begin surviving independently in 1892, seven years after accepting his first and only job as clerk in 1885. He had already started having illustrations and paintings accepted and printed or exhibited from 1884 onwards.

A Break in the Biographical Narrative

It may be coincidental, but it is hardly surprising that some 20 years after his clerkship (and drawing for hire on the side), Arthur Rackham achieved enormous popular success with his illustrations of Washington Irving's *Rip Van Winkle* (William Heinemann, London, 1905), *see* pages 88–90. He was already a widely published illustrator, but it is agreed among critics and lovers of illustration, that Rackham had attained maturity in this work, and that this book would propel him

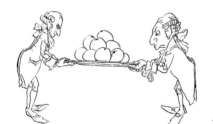

through another 45-odd books, poems, and collections, nearly all classics.

Washington Irving (1783–1859), named after American president George Washington, is considered North America's first man of letters to earn his living by his writing. He became a master of the American short story, and was the first popular writer to ground his settings firmly in America. Critics of his style were numerous (including Poe), but few could or now can deny the everlasting singular mythic qualities of *Rip Van Winkle* and Ichabod Crane from *The Legend of Sleepy Hollow* (*see* pages 97–100), which Irving penned as the fictional Dutch historian Diedrich Knickerbocker in what is referred to as *The Sketch Book* (essays and stories written and published during 1819 and 1820 by his pseudonymous alter ego Geoffrey Crane mostly on American themes).

Arthur Rackham clearly found much to play with in Rip: the short story with its natural setting, 'odd little Dutchmen', flora and fauna and, of course, Van Winkle himself (who, like Rackham, was an all-around good fellow on the surface, not known for his industriousness, and a great storyteller, as the people close to him knew). The process of aging too, in the drawing, clearly reveals Rackham's maturity as a draughtsman and his command of the new means of production, both of which will be discussed shortly.

Rackham as a reader can be viscerally felt when Irving writes, after Van Winkle's descent and awakening, 'Having nothing to do at home, and being arrived at that happy age when a man can be idle with impunity, he took his place once more on the bench at the inn door, and was reverenced as one of the patriarchs of the village, and a chronicle of the old times "before the war." It was some time before he could get into the regular track of gossip, or could be made to comprehend the strange events that had taken place during his torpor.' Naturally, it did not take much time for Rackham to get into the swing of things, and I would replace the word 'torpor' with 'apprenticeship.' It is obvious that Rackham had hardly been 'idle' when he was in his prime, but after 20 years, he had reached a point when he could create his pictorial world 'with impunity.' Not many are so happy. And Rackham lost no time in getting to it, in making his own real and fantasy worlds. Unsuspected worlds that exist to our day.

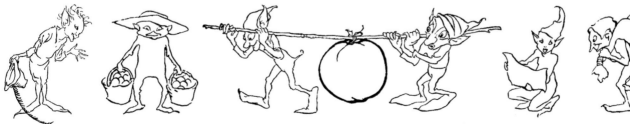

The Golden Age of Illustration

The Golden Age of Illustration designates a period of technological advances, availability and excellence in book and magazine publishing. New printing techniques, particularly in half-tone and full-colour were developed to reproduce on a mass scale. The production of paper and rapid distribution networks via the railways came together to give artists rich tools to faithfully reproduce their art.

In J.M. Dent & Co.'s very first 1907 edition of *The Ingoldsby Legends* (*see* pages 53–54), Rackham had reproductions enlarged and 'reconsidered', and went through what he called 'a careful overhauling' of all the illustrations in the book. This would become a habit of his. The publishers called this version (after the 1898 version of the same name on page 52), 'something like an "Edition Définitive de Luxe"' of the original, in which:

'Mr Arthur Rackham has entered heartily in the wild humour and phantasy of this favourite old classic … The coloured pictures, which owe so much to their delicacy of tint and fine line drawing, have all been reproduced by the Graphic Photo Engraving Co. in the latest and highest development of the three-colour work, and the Publishers owe them thanks for their great care in copying these originals and for their adequate and admirable results.'

Producing Quality Illustrations

The Golden Age of Illustration is generally described as lasting between the 1880s and the 1930s when photography radically altered the role of publishers and illustrators. The popularity and excellence of both periodical literature and, especially, so-called children's literature produced a vast demand for quality illustrations and imagination.

It comes as no surprise that the moving image was also coming into being at the time (a version of *Rip Van Winkle* was made in 1902). But far from replacing illustrated magazines, the cinema and later television, gave rise to new publications, increased the use of photography and while the Golden Age of Illustration evolved, it did not disappear.

At one point Walt Disney contacted Rackham; though no collaboration came of that, Disney did have his illustrators study Rackham's work. Similar stories continue today with Marvel's success at the box-office, manga and anime; surrealism and pop art would not be what they are without the Golden Age of Illustration. With no exaggeration one could say that the period gave rise to the first grand explosion of pictorial art available to the masses, the second being the moving image, the third being the rise of the digital age.

To name a few of the more familiar artists of the Golden Age of Illustration: Sir John Tenniel (1820–1914), Kate Greenaway (1846–1901), Edward Penfield (1866–1925), Beatrix Potter (1866–1943), Rackham, Aubrey Beardsley (1872–98), Edmund Dulac (1882–1953), N.C. Wyeth (1882–1945) and many others.

The Start of Rackham's Success

After publishing many immature pen-and-ink drawings and watercolours, which Rackham himself considered to be more or less hack work, he started contributing regularly to the *Pall Mall Budget*, then in 1893 to the *Westminster Budget* and the *Westminster Gazette*. In 1892 he painted a remarkable *Self Portrait* in oil that shows the skills of a painter who likely could have followed the path of painting for museums and exhibitions, and, certainly, portrait painting, which was in vogue at the time (and at which his future wife, Edyth Starkie, excelled).

In a catalogue from the Clarke Historical Library and Central Michigan University, it is written that, 'Rackham's success was connected to contemporary improvements in the means of reproduction, namely photography. Unlike previous illustrators, who relied on an engraver to cut clean lines on a wood or metal plate used for printing, Rackham could have his pictures photographed and mechanically reproduced. This change removed the middleman between Rackham and his finished product. In particular, it allowed Rackham to display his particular gift for line, which an engraver, lacking Rackham's talent, likely could not render onto a printing plate.'

With such highly talented makers of images as those mentioned above, there was an immediate, visible, tangible and important market in illustration. In addition to advances in printing technique, the removal of 'the middleman' in selling art was, especially beneficial to the young, rather private artist who was Arthur Rackham. His clerkish side became very useful in being able to work his way through his field, and to arrive early at the illustrator's goal: namely, to publish illustrations for books.

Delight and Emotion Aroused

Arthur Rackham said in a speech in 1910, 'The most fascinating form of illustration consists of the expression by the artist of an individual sense of delight or emotion aroused by the accompanying passage of literature.'

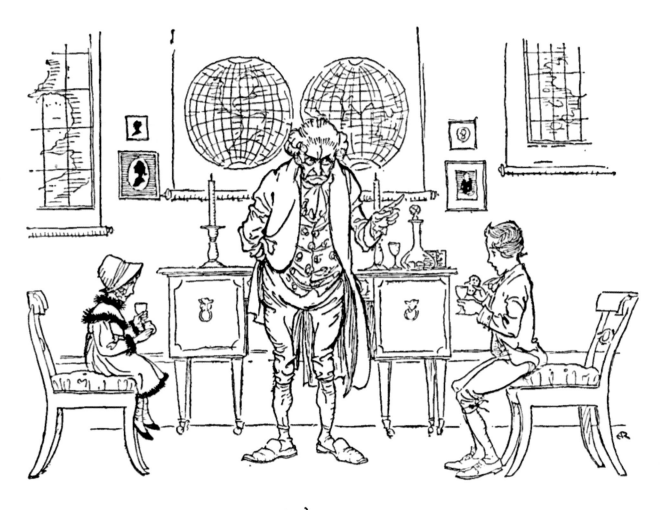

As a complete bibliography would constitute a work in itself, it is enough here to say that between 1895 until his death in 1939 (plus two original posthumous works) Rackham illustrated over 45 major works, many first in deluxe editions, most of which were followed by inferiorly printed trade additions. There is no question that he was not only one of the most prolific, but that he is arguably the most influential book illustrator of all times in any language in the modern era. Just to name a few authors here, Rackham illustrated major works by Aesop, Barrie, the Grimm brothers, Shakespeare, Irving, Kenneth Grahame, Poe, Anderson, not to mention collections of fairy tales, legends and myths or collections including his own writing. Discussions of many of these works will follow shortly and can be seen from page 28.

Regarding so-called children's literature as a source of illustration, Rackham put it best when he wrote in *The Junior Book of Authors* (1934):

'*I can only say that I firmly believe in the greatest stimulating and educative power of imaginative, fantastic, and playful pictures and writings for children in their most impressionable years … Children will make no mistakes in the way of confusing the imaginative and symbolic with the actual. Nor are they at all blind to decorative or arbitrarily designed treatment in art, any more than they are to poetic or rhythmic form in literature. And it must be insisted on that nothing less than the best that can be had – cost what it may (and it can hardly be cheap) – is good enough for those early impressionable years when standards are formed for life. Any accepting, or even choosing, art or literature of a lower standard, as good enough for children, is a disastrous and costly mistake.*'

from what R.B. Kitaj called 'The School of London', Lucien Freud (1922–2011), said that, 'The longer you look at an object, the more abstract it becomes, and, ironically, the more real.' No doubt his grandfather Sigmund Freud (1856–1939) would agree with him.

It is unlikely that the two figures Sigmund and Arthur had much to do with one another, though they surely shared quite a bit of reading. Lucien's take on painting a model was largely psychological and took place in an entirely different, albeit British, society but if one thinks of Rackham's faerie as a world of other beings – his elves, goblins, fairies, animate plants and masks, etc. – it is easy to imagine that the live model gave a psychological character to his figures that would otherwise have been absent. Personification is taken to its highest form in many of Rackham's line drawings and watercoloured pen-and-ink drawings. It is easy to wonder what he is personifying, the object, or the imagination of a being growing inside one's psyche that has no other way out than on paper or canvas.

Rackham may have failed to achieve the social status of a great so-called 'high artist' in part because of his business model (had he primarily exhibited in galleries and museums he would have been forced to make different choices) and perhaps because of his amiable

and dutiful manners as an English clerk never left him; that role never became a persona he could use in high art. Ironically, I find that Marcel Duchamp (1887–1968) had very similar airs to Rackham though he was never a clerk. Franz Kafka (1883–1924) who earned his living as a clerk, used his social status merely to support himself and write independently, which is to say, to write what he alone wished. Then again, aside from his novella *The Metamorphosis* (Kurt Wolff Verlag, 1915), Kafka never completed a single one of his novels. Nonetheless, an astute selection of, say, 1,000 pictures by Arthur Rackham – drawings, watercolours, mixed techniques, oils –would be hard to match by many great artists in the lofty realms of high art.

Find Him If You Can

In a 1904 pen and ink and watercolour, commissioned originally by *Punch,* called *Common Objects at the Seashore,* there are some hundred-odd mostly human and 'goblinesque' figures packed into a picture only 46 x 36.5 cm (18 x 14 in) in size. Hamilton writes '[…] that there appear to be four self portraits among the figures.'

It is a signature trait of Rackham to hide goblins, elves, faces, odd figures, himself and other familiar characters in his often numerously peopled pictures, several of which can be found here in this small collection.

This is not to mention the figures to be found lurking in the abundant flora and the leaves of animate trees, or the corners of densely loaded interiors. While Rackham may have believed that a magazine illustration was not meant for contemplation, and seen only briefly, he certainly made it possible in the vast majority of his pictures to go back time and time again.

In the early twentieth century, a long-lasting partnership with publisher William Heinemann began. Deluxe editions of many books, which sold out early, were finely bound; trade editions were released simultaneously to capture a wider audience and Rackham began to exhibit and sell his original paintings (for example, at Leicester Galleries in London). This became another major source of income.

This business model would become part of Rackham's art work and can be considered a precursor in the field of promotion and marketing through the art itself as opposed to the promotion-for-promotion's sake that is the norm today in art, as elsewhere.

Critic Richard Dorment rather smugly dismisses Rackham's and high-art interest:

'Nowadays, we can easily see that it was a short step from Rackham's version of the eighteenth century to the one Walt Disney gave us in the animated film of Cinderella. This is art in fancy dress, art that is in such good taste, so unserious, and so loosed from reality that it couldn't possible [sic] offend anyone … I hate to say this, but I don't think many modern children would be even slightly troubled by Rackham's goblins and witches, or even particularly interested in his princesses and princes.'

He seems to be unaware of the millennials, emos and goths who would find, I believe, the comparison with Disney distasteful. Not to mention the fact that Rackham himself seemed less interested in Disney than Disney in him. While Disney comes to mind when considering Rackham, he must be considered an entirely different phenomenon, like him or not.

As his watercolours clearly prove, and a closer look beyond the fantasy elements of his art show, Rackham was hardly 'loosed from reality'; indeed, in many respects he was very down to earth – his premonitions of darkness and evil were, in a word, subtle. It is true that he may have thrown in superfluous elements from time to time – such as 'filler' elements used in the upper fifth of many illustrations to make a page as opposed to make a focused pictorial composition. But this generally only becomes apparent after seeing dozens or even hundreds of illustrations in a short time. This is a rather forced critique.

Rackham's Subjects

I was surprised to learn how often Rackham used, and depended on, real-life models, some from his family, most others paid employees of the artist. For a figurative artist there is no greater challenge than painting a live subject. Whatever the style, the living body infuses the painter with a will to reproduce to the un-reproducible. The great contemporary figure painter

There are three main types of compositions used by Rackham: Brueghelesque à la Pieter Breughel the Elder (*c.* 1525–69), most notably paintings with numerous characters in movement; pictures with one, two or three main characters interacting, surrounded by a lush environment; and a lush environment of often animate flora and fantasy figures with main characters, again interacting, in the bottom third of the picture.

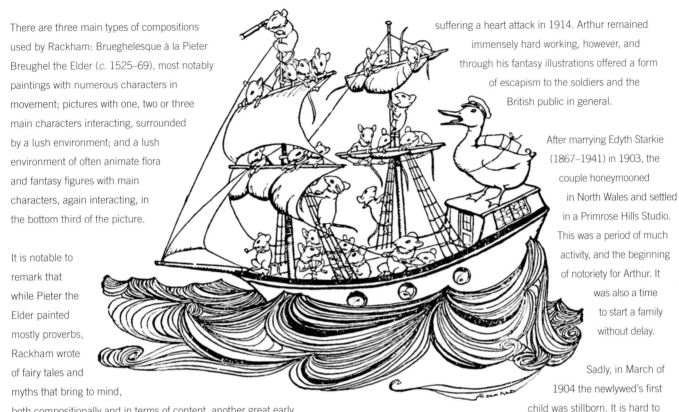

It is notable to remark that while Pieter the Elder painted mostly proverbs, Rackham wrote of fairy tales and myths that bring to mind, both compositionally and in terms of content, another great early Flemish painter, Hieronymous Bosch (*c.* 1450–1516) who had a singular vision of religious themes.

It is possible, and indeed enjoyable, to 'flip' through books illustrated by Rackham to get a sense of the overall content and motion of his reading. But it is in the contemplation of a great number of his pictures that one sees Rackham in depth, an elusive depth I would add, in that one often cannot tell whether his figures are meant to be pure fantasy, caricatures or the story's secondary people, or symbolic caricatures of the psyches of caricatures, whether personified trees and plants, or fantasy or real characters.

The War Years

After his marriage to Edyth Starkie in 1903 and the birth of their daughter, Barbara, in 1908, it's not long before they are into the difficult years of the First World War. This was a period of personal difficulty for Arthur Rackham, with his wife dealing with ill health and suffering a heart attack in 1914. Arthur remained immensely hard working, however, and through his fantasy illustrations offered a form of escapism to the soldiers and the British public in general.

After marrying Edyth Starkie (1867–1941) in 1903, the couple honeymooned in North Wales and settled in a Primrose Hills Studio. This was a period of much activity, and the beginning of notoriety for Arthur. It was also a time to start a family without delay.

Sadly, in March of 1904 the newlywed's first child was stillborn. It is hard to imagine the grief of Edyth and Arthur, and also would-be grandmother Anne Rackham, but there is a melancholic strain in much of Starkie's work and portraits. This combined with her long-term ill health no doubt had an effect on her career though, in personality, she was known for her wit, charm, and vivacity.

She was a staunch defender and critic of her husband's work and he followed her advice on many occasions, as well as supporting her career by buying materials and paying for models. While she faded into the background of Rackham's fame there is no indication that she regretted it. She studied painting in Paris in her teens and had exhibited at the Royal Academy three times before meeting Arthur.

For an Irish girl, in times of Irish mass emigration towards America and lands elsewhere, Edyth was privileged to be able to travel around Europe with her mother for two years, starting when she was 16 years old. She grew a fondness for Germany which, until the First World War, she shared with Arthur, visited many of the great capitals and thus acquired an education few were (and are) allowed.

A Marriage of Mind, Art and Companionship

By all available accounts, the Rackham household was a peaceful and joyous one. After several major contracts, exhibitions, and completed books, Edyth and Arthur Rackham had their only surviving child, Barbara, in January of 1908. Barbara lived a long and full life and died in 1993.

In writing about where her mother spent most of her childhood, at Cregane Manor, Rosscarbery, near Cork, it seems as if Barbara were writing about a Rackham painting and an atmosphere that lived on in her own life with Edyth and Arthur:

'Dotted about the grounds were the little whitewashed cottages of the tenants who ministered to the state in various ways, digging the land, grooming the horses, fishing in the bay, providing their children as boot-boys and their grandmothers to sit and poke the fire and tell apocryphal stories of Starkie ancestors for my mother to pass on to me.'

This was a kind of world that dominates Rackham's painting, work, signs of family life and correspondence. But he and Edyth were not blind to the ominous signs of upheaval, not merely industrial and technological, but also social. The fact that both had a liking for Germany and its art would soon wane after the birth of their daughter. Their ties to Germany were more than superficial.

The Threat & Reality of War

Edyth had a brother, Rex, who had served as an officer in the German Army and who died in the 1890s of tuberculosis. Edyth had stayed in touch with her sister-in-law Alle and Alle's sister Dr Lili Müzinger, and enjoyed a comfortable friendship and correspondence in the pre-war years. Lili stayed with Edyth when she came to England.

To make a long story short, Lili was accused of being a German spy at the beginning of the war and was interned in Italy. Around the same time, Rackham lost six illustrations due to what was considered a deliberate fire at an exhibition in Leipzig Museum.

Lili was later allowed to go to Switzerland and ended up in Berlin, apparently exonerated of the accusations made against her. She expressed great dismay with Edyth for failing to stay in close contact, assured the Rackhams that Arthur's paintings and work would not be destroyed and told Edyth that 'after the war your husband will have back all his treasures'.

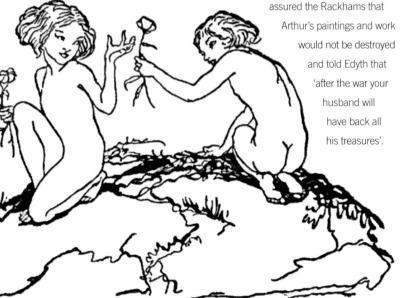

Still, due in part to this misunderstanding with Lili, and certainly because of the emotional and psychological burdens of the First World War (exacerbated by her family connections with its nemesis, Germany), Edyth had a heart attack in 1914 and was very ill throughout the fighting.

Although his income had fallen significantly Rackham contributed to the war effort by donating illustrations to various charity publications. He also had to care for his daughter and his ailing wife. It does not appear that he stopped working for a moment.

While it has been said that Rackham was rather detached from the real world, watercolours, paintings, and illustrations for the Brothers Grimm (see pages 106–109), for example, from the early pre-war and war years are replete with examples of an artist describing and forewarning the terror as best an artist can through his medium.

While he was not what is called a politically engaged artist, Rackham was humanly engaged and clearly fulfilled a role that only artists of his stature can: they can offer hope and relief, however brief the latter may be.

The Rise of Escapism

Artist, historian, critic, and thinker John Ruskin (1819–1900), in writing about his conception of fantasy art and literature, considered the imagination a defining aspect of humanity and a basis for its highest art. Essayist George Landlow wrote that, 'Ruskin's valuable perception that fantastic art and literature form part of a continuum which includes sublime, symbolic, grotesque, and satirical works is particularly useful to anyone interested in this mode, because fantastic art does, in fact, share much with satire and symbol, caricature and sublime. After all, much of the delight of Caldecott's courting frog, Griset's fisherman, and Rackham's witches arises in the way they caricature normal humanity, and similarly, when we receive pleasure from this last artist's wonderfully humanized trees, it is precisely because they are so human; because, in other words, they share so much of the human that they enable us to see ourselves better because we see ourselves in such guise.'

While adepts of realism and fantasy literature and art have been arguing with one another for a couple of centuries now, it seems without a doubt that the imagination is able to perceive reality, transform and interpret it in ways that are both rational and irrational,

largely because the picture, writing, or canvas itself is a model that exists not merely because of this or that psychological character, but also because of its essential artifice, without which it would not exist.

Later on in Life

A brief look at Rackham's art shows that he could have, in terms of skill alone, or mastery of his art, painted in many different genres, as Picasso did, for example, or as many authors write in several genres. But art cannot be judged for what the artist does not intend to do, it must be judged for what it does and how it does it, in terms of its specific art. The technical requisites of what makes a painting or an illustration – line, colour, movement, composition, and so on – were clearly one of Rackham's chief concerns. And he can rightfully claim his place among the masters.

How his art affects his viewers is another question and is neither static nor time-bound. It is not surprising that Rackham grew in popularity during the war years, not because of increased availability, but because his art allowed people at

home, as wells as soldiers, a brief moment of bittersweet respite from the terror of war.

Let it be clear, Rackham never went broke; he continued to earn a very good living after the First World War, especially if one considers the general state of the world economy at that time. Nevertheless, his earnings as an artist, despite working and exhibiting as often as he had until 1920, which was his high point, gradually and significantly dwindled until the time of his death.

The Aftereffects of War and a Personal Economic Downturn

An astute businessman, Rackham was also investing in the Stock Market, which allowed him to maintain a household staff and a large house in the country. There are many reasons for his decline in earnings, again not the least of which was the economic devastation that followed in the First World War's wake.

There were also many personal reasons that put a strain on how his earnings were spent. Just to name a few, in the 1920s Barbara was sent to school, his mother died, a couple of his siblings died, and his and his wife's health began to deteriorate. In 1930 Edyth Rackham fell seriously ill for three months.

Still, on the average, Rackham managed to tend to affairs, illustrate at least one major work per year, by authors including Milton, Shakespeare, Dickens, Irving, major fairy tales, and more. He also went on holiday with his daughter in Europe and participated in yearly exhibitions in New York, in England at the Royal Academy and the Royal Society of Portrait Painters. The list of his activities and events goes on and on.

From *Rip Van Winkle* (1905) to the first posthumous edition of Kenneth Grahame's, *The Wind in the Willows*, The Limited Editions Club (1940) (*see* pages 46–49), and, essentially, a major book publication per year and annual exhibitions – by any account, Rackham's output was prodigious. He was also implicated in the printing process for nearly all of his deluxe editions and 'overhauled', as he describes it, numerous illustrations. It is not my concern in this essay to rate the quality or mastery of individual pictures or, for that matter, books, but it seems that his seriousness was affected by the quality of the literature he was illustrating. This should be made apparent in the brief comments for the reproductions of Rackham's work used to illustrate this book.

Illustration was not merely a decorative art for Rackham, but also an interpretive art. Naturally, there are many books he (and others) illustrated that have no need for pictures at all; other books are based on stories where the pictorial element is part and parcel of the writing; still others are stories told primarily by the pictures alone. Rackham was a master of all three forms. The captions (*see* pages 28–125) to the reproductions here will be complementary to this essay.

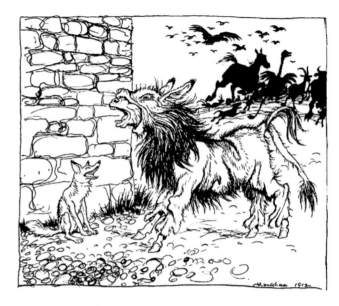

Rackham's Last Decade

The last decade of Rackham's life was hardly an idle one as an artist and a family man. His technique was in high form and while he had to deal constantly with his health problems and those of his wife, he grew increasingly tired as the years went by, but he never stopped working. In 1935 Barbara Rackham married and in 1938, his first grandchild, Martin, was born a year before Rackham died in September of 1939. Edyth Rackham died in March of 1941. Barbara was married twice, had three children by her first husband, and died in 1993.

In 1939 Germany attacked Poland on 1 September and less than a week later Arthur Rackham died of cancer having just completed the illustrations to one of his most beloved books, Kenneth Grahame's *The Wind in the Willows*, which would be published (posthumously) in New York, the following year thanks to George Macy and his Limited Editions Club. The two had met in New York in 1927. Rackham had had to decline illustrating the book when Grahame asked him thirty years previously, due to a full slate of already commissioned works.

Rackham had been trying late in life to find an English publisher, to no avail. When Macy asked him if he would do the illustrations for a Limited Editions Club edition, Macy wrote that: 'Immediately, a wave of emotion crossed his face; he gulped, started to say something, turned his back on me and went to the door for a few minutes.' So much for the stoical clerk!

Naturally Rackham agreed and produced what he considered to be one of his finest works. It was certainly one of his favourites. Starting in 1926, not to diminish the interest of previous books or others during the same period, Rackham illustrated Shakespeare's *The Tempest*, Irving's *The Legend of Sleepy Hollow* (1928), Goldsmith's *The Vicar of Wakefield* (1929) (see pages 101), Dickens's *The Chimes* (1931), Walton's *The Compleat Angler* (1931), Hans Andersen's *Fairy Tales* (1932), *The Arthur Rackham Fairy Book* (1933) (*see* page 124), Christina Georgina Rossetti's *Goblin Market* (1933) (*see* page 85), Browning's *The Pied Piper of Hamelin* (1934) *Poe's Tales of Mystery and Imagination* (1935), Ibsen's *Peer Gynt* (1936), Shakespeare's *A Midsummer Night's Dream* (1939) (*see* page 55) and, lastly, in 1939, Grahame's *The Wind in the Willows* (see page 46).

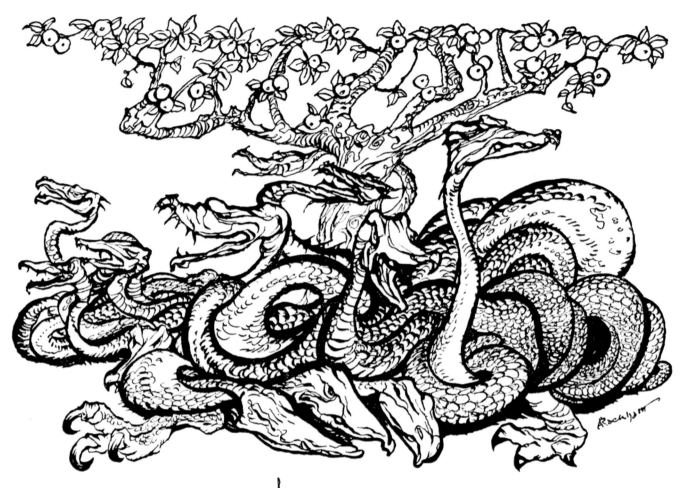

As these books show, if ever there was a doubt, Arthur Rackham, the artist, was a master of the craft of illustration. His choice of works and at least part of his psyche leaned toward the playful and the grotesque. The sexuality, as depicted in his numerous fairies and Naiades, for example, are often reserved and waif-like, which were products of his time. Many of them, as one will see while looking through the illustrations, are models, wrought not by a camera as many of today's more reserved female creatures, but by an imagination that mixed the mores of his time with the flights of fancy of the works he illustrated and the mind at play in fairylands (which were very much a part of the popular imagination during Victorian times, as they remain today, though for different aesthetic reasons).

Hide and Seek

In Victorian times it can be said that sexuality, and an unfettered imagination in language, thought, darkness, and evil, had to be hidden from direct view, to be disguised, to be dressed up in sober or whimsical costume to get through the moral and religious censors and filters of Britain, in particular, and of the Western World in general at that time.

Fantasy and its plethora of elves, fairies, goblins, animate flora, Naiades, demi-nudes and odd caricatures were tools and signs for satire, play and fancy – a way to depict the workings of the mind without actually spelling it out for the viewer. It is no surprise that readers and art lovers

were intrigued, fascinated and moved by Rackham's signature style and the complexity of a large number of his pictures, and the play between them in any given book.

His single watercolour tableaux and his rarer oil portraits are also proof of a definite mastery of his craft. His subjects are reserved and, for the most part, somewhat melancholic.

While I hesitate to ascribe psychological readings to all works of art, there is no denying that the sum total of Rackham's pictorial output was both a product of his times and a reflection of the joyful, yet rather reserved and somewhat sorrowful circumstances of his life. There were many untimely deaths of children and adults, and much illness.

Rackham also lived through an era that he was perhaps not entirely suited for, an industrial revolution, and a cataclysmic war. That the First World War

issued from such apparently moral, religious and sober times was a shock to the world. While not succumbing to that shock, Rackham felt it and this can be seen in many of his pictures and the books he chose to illustrate.

Merely a Man of his Times or an Artist for the Ages?

I find myself restrained here by length to discuss the worth, value and repercussions of fantasy literature and art that is commonly said to have its modern origins in nineteenth-century England and in the myths and legends of Greece, the Nordic countries and Europe, not to mention Native-American mythologies. But let it be stated that fantasy art is alive and well – often in the form of nostalgic interpretations of the artists of the Golden Age of Illustration, through wholly created worlds as that of J.R.R. Tolkien (1892–1973) or the tales of H.P. Lovecraft (1890–1937), and again through science fiction, New Age spirituality, comic books, music and movies.

While we are accustomed today to the depiction of overt sexuality, violence, mystery, evil and horror, we are no less intrigued by what we do not know and cannot find. Without that element there would be no story. And simply because we pretend to be naked does not necessarily mean that we are less prudish and squeamish than our predecessors. It could be simply that we are numb to feeling and that this overt representation is not entirely realistic, but yet another mask, another way to push our fears and anxieties into unattainable places. In fantasy, still, we can try to go where we will.

The sheer number and mass of Rackham followers, publications, reproductions and originals – on every sort of support imaginable – is a fair indication that his art is here to stay. There will no doubt be readings and re-readings of his work in books such as this, and museums and galleries worldwide for quite some time.

Whether Arthur Rackham was as concerned about being a 'high' or 'pure' artist as opposed to a 'popular' one, is no doubt beside the point. To a great measure he produced the art he wanted to make. Even more importantly, perhaps, is that he never neglected a chance to 'overhaul' or perfect not only his craft, but each individual picture.

In Rackham's extensive correspondence, fragments of which can be found in various books, articles, and essays, as well as on the countless internet sites that keep popping up about

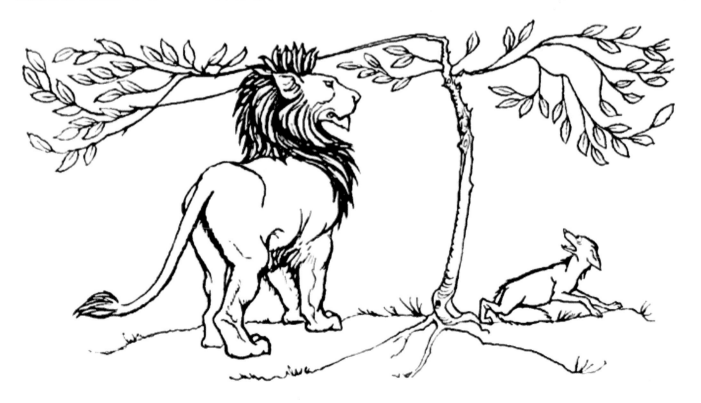

Rackham and his art, one finds an opinionated man, aware of his times, and seriously concerned about the real future of the world and its youth. While this quote was written later in life when his Unitarian vision of the world had returned to the surface, it also sounds like someone who could be talking about how, today, we have treated our environment. Allow me to end on his words:

'I think [...] the main charge to be laid against the wonderful Victorian days – when the world was so elated at "conquest of nature" that it was not seen what the penalty must inevitably be of this eating of the fruit of the tree of knowledge of good and evil ... Art may indeed be under a cloud. But if it is not the spirit of the Creator working in us I do not know what it is. And it cannot be eternally killed.'

Children's Books

Despite his varied pieces, Arthur Rackham was perhaps most well known for his illustrations for children's books, including of course *Alice's Adventures in Wonderland* and *Peter Pan in Kensington Gardens*.

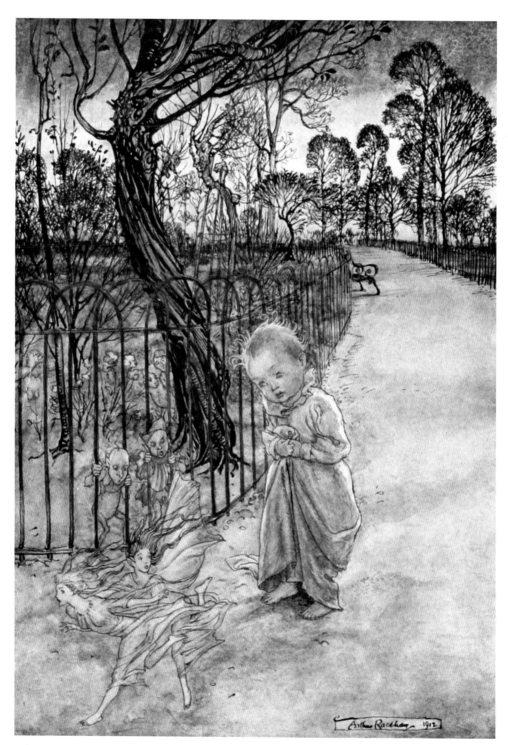

He was quite angry when these two ran away the moment they saw him

J.M. Barrie, *Peter Pan in Kensington Gardens*
• Hodder & Stoughton, London, 1906

Peter Pan was quite a curious little fellow at only a week old. This frontispiece displays the subtle wash of colour with pen and ink, which Rackham would continue to experiment with until the end of his life.

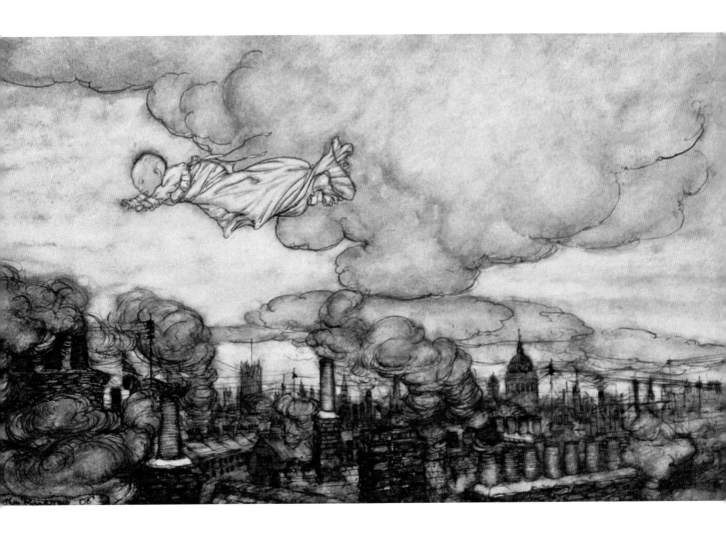

Away he flew, right over the houses to the gardens
J.M. Barrie, *Peter Pan in Kensington Gardens*
• Hodder & Stoughton, London, 1906

Colour lithography was essential to the rise of the Golden Age of Illustration. One sees here a dark aspect of Rackham's vision of London, a reminder of his wariness of industrial progress.

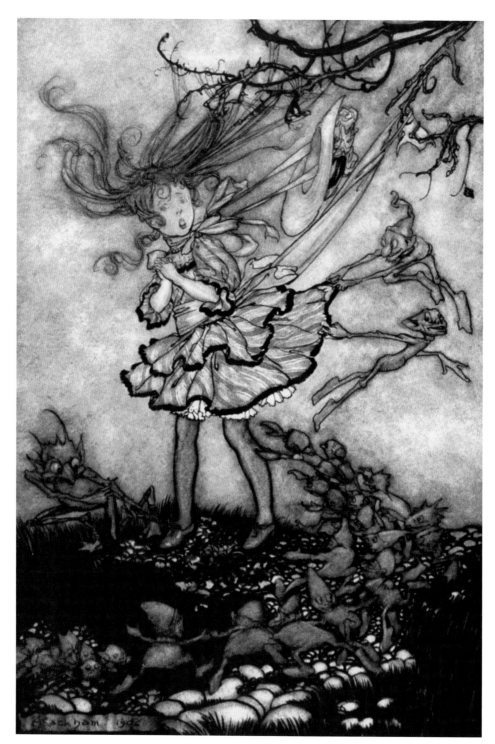

They will certainly mischief you

J.M. Barrie, *Peter Pan in Kensington Gardens*
• Hodder & Stoughton, London, 1906

These little creatures are the bad ones among the fairies. Rackham was no doubt moved by Peter Pan who believes that 'house-swallows are the spirits of little children who have died'.

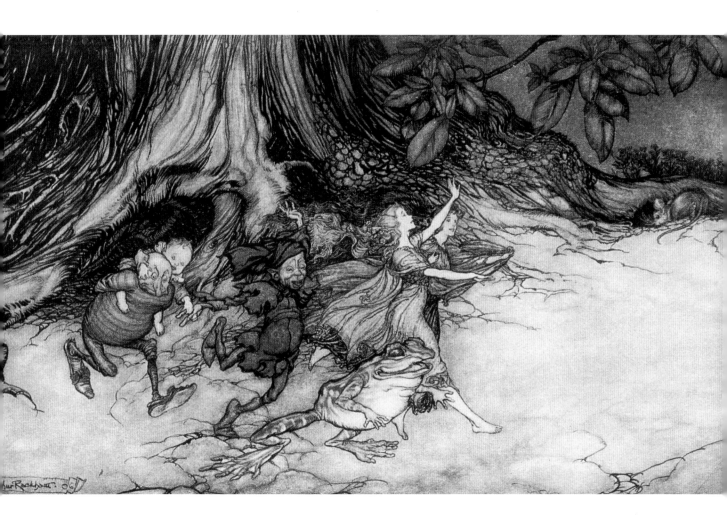

When they think you are not looking they skip along pretty lively
J.M. Barrie, *Peter Pan in Kensington Gardens*
• Hodder & Stoughton, London, 1906

The little people and personified toad, amidst an abundant nature rich in colour and lorded over by age-old trees (from which no doubt they have emerged), are typical examples of Rackham's faeries.

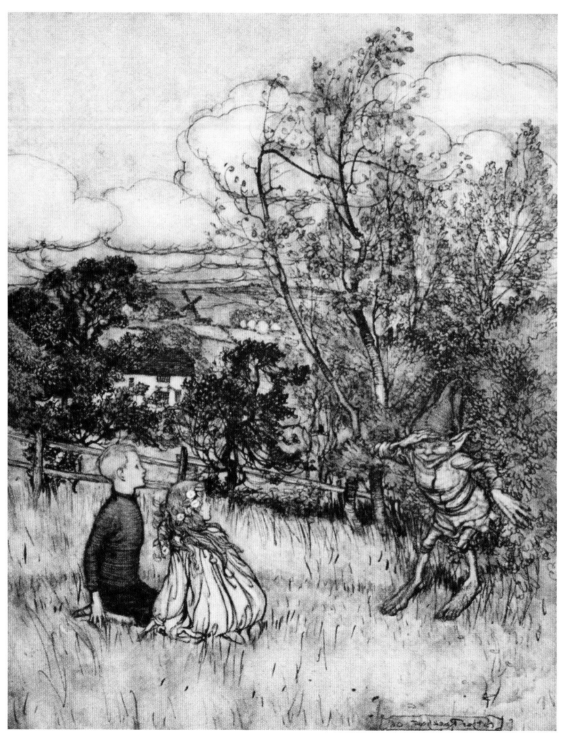

In the very spot where Dan had stood as Puck they now saw a small, brown, broad-shouldered, pointy-eared person
Rudyard Kipling, *Puck of Pook's Hill*
• Doubleday, Page & Co., New York, 1906

Puck is an elf in Kipling's book and a fairy in Shakespeare's *A Midsummer Night's Dream* who is also known as Robin Goodfellow, one of Rackham's favourite literary characters.

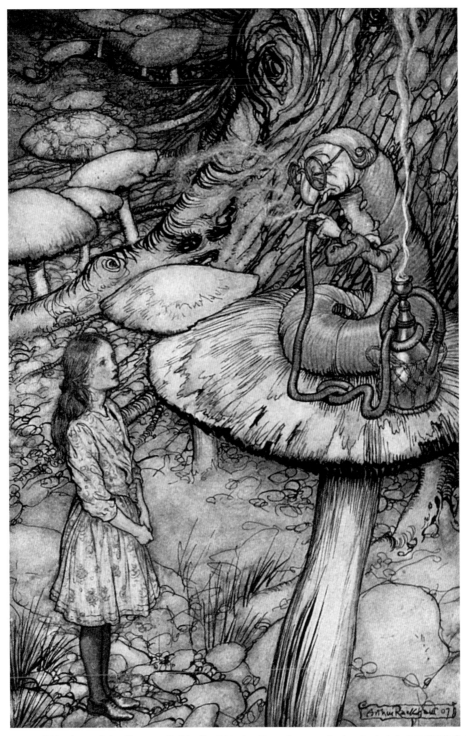

Advice from a Caterpillar

Lewis Carroll, *Alice's Adventures in Wonderland*
• William Heinemann, London, 1907

Sir John Tenniel had pretty much monopolized readers' minds regarding their visions of Alice. Rackham's Alice still respects the old master but he appropriates the work as his own.

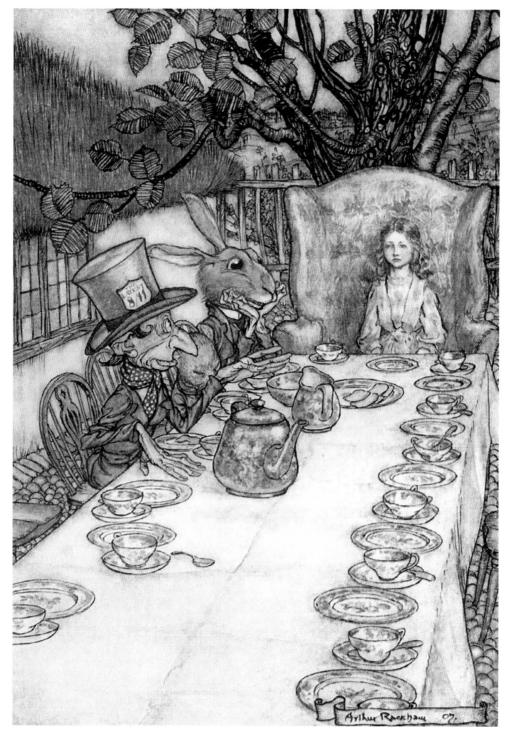

A mad tea party

Lewis Carroll, *Alice's Adventures in Wonderland*
• William Heinemann, London, 1907

While showing respect to the old master (Tenniel), Rackham 'updates' Alice.
This is the early stage of his mastery of the main Golden Age printing process.

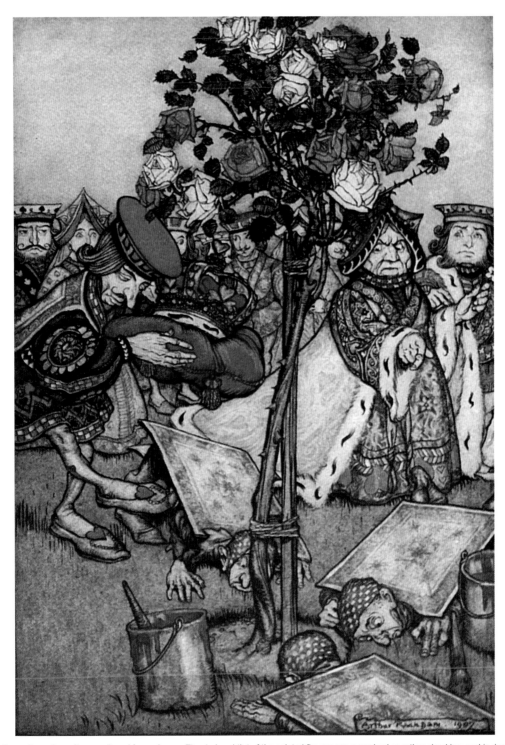

**The Queen turned angrily away from him and
said to the Knave, 'Turn them over'**

Lewis Carroll, *Alice's Adventures in Wonderland*
• William Heinemann, London, 1907

The dark red tint of the painted flowers was perceived as rather shocking, and is due to
Rackham's playful wit, new reproduction possibilities and a mimicry of the Queen's anger.

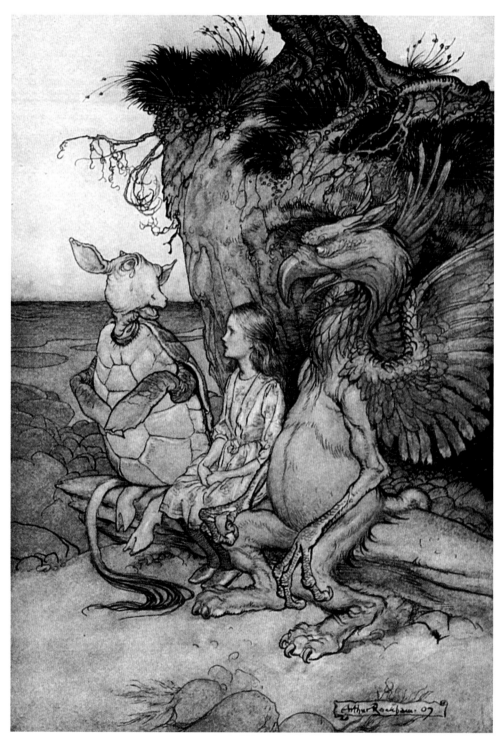

The Mock Turtle drew a long breath and said, 'That's very curious'

Lewis Carroll, *Alice's Adventures in Wonderland*
• William Heinemann, London, 1907

One can imagine the pleasure Rackham may have shared with the Mock Turtle who had 'found out a new kind of rule'. It is no exaggeration that he would often use the text to refer to his art or his life.

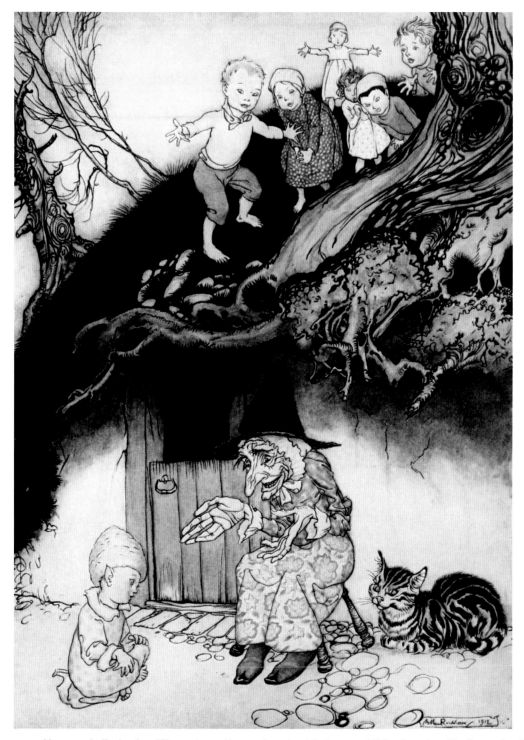

There was an old woman who lived under a hill

The Nursery Rhymes of Mother Goose
• William Heinemann, London, 1913

A very old woman has entered the language of Mother Goose here. The disproportionate size of the cat and hands is not typical of Rackham but curious children and roots of trees appear throughout his work.

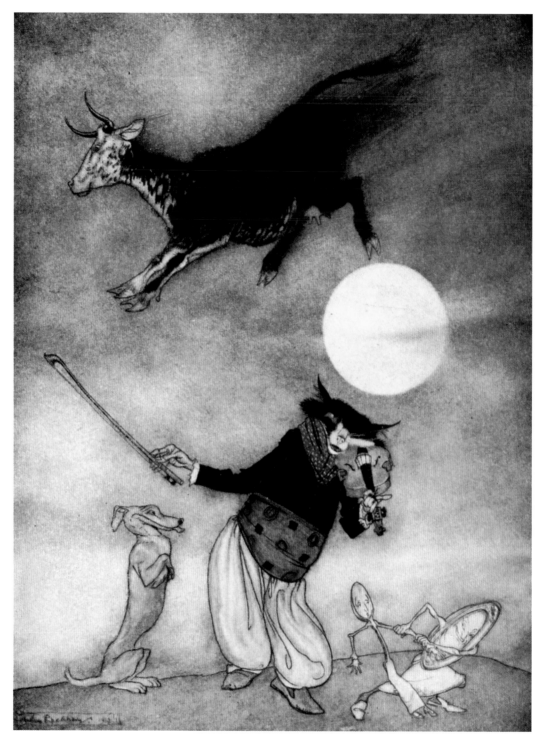

'Hey! Diddle, diddle, the cat and the fiddle'
The Nursery Rhymes of Mother Goose
• William Heinemann, London, 1913

This ditty reminds one of Rackham's musical penchant, and is an unusually minimal example of his sense of colour and the sharpness of the photomechanical and lithography colour printing process.

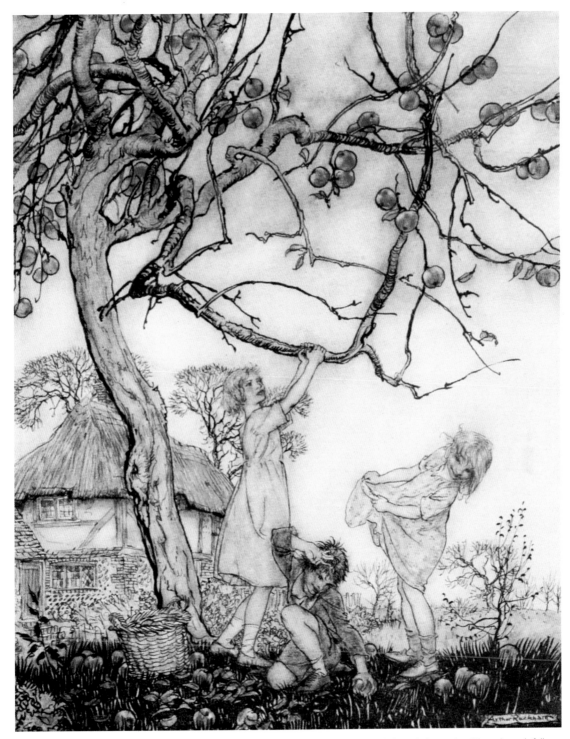

Untitled (for the poem 'Barnack Beauty')
Eden Phillpotts, *A Dish of Apples*
• Hodder and Stoughton, London, 1921

Phillpotts was a minor poet born in India who is quoted as saying: 'The universe is full of magical things patiently waiting for our wits to grow sharper.'

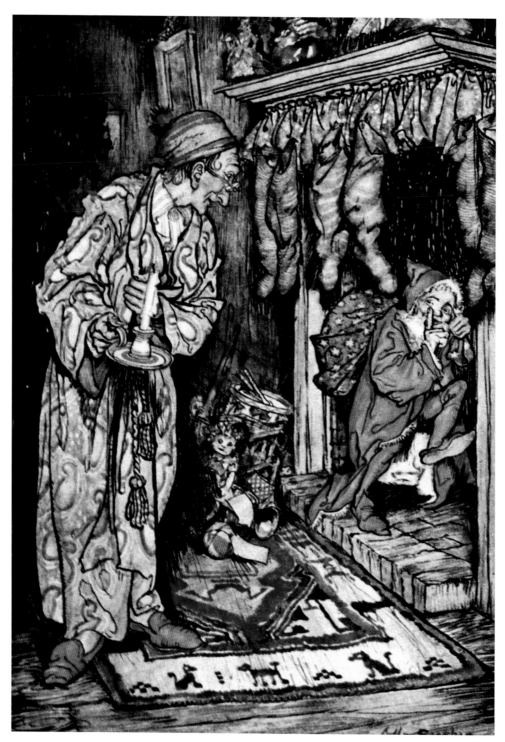

He spoke not a word, but went straight to his work...
Clement Moore, *The Night Before Christmas*
• J.B. Lippincott, Philadelphia, 1931

Time and again one can see that Rackham worked his own life into many of the books and poems he loved. He was known to disappear to his studio table and work for hours, filling the stockings...

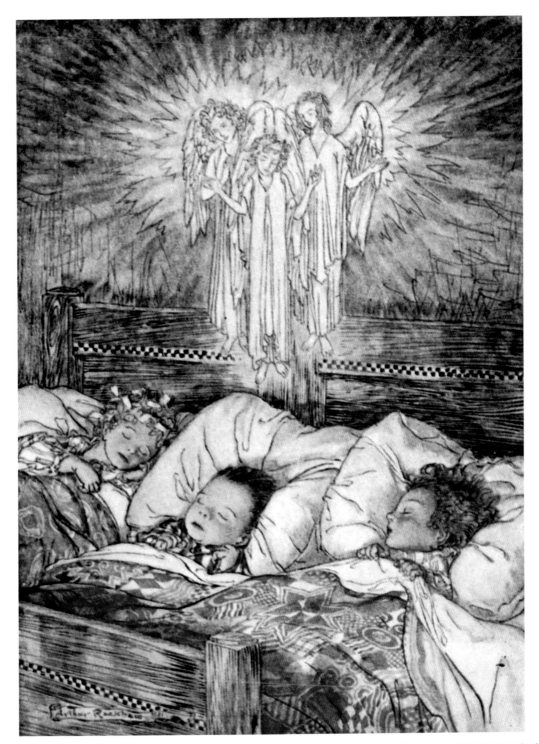

The children were nestled all snug in their beds...
Clement Moore, *The Night Before Christmas*
• J.B. Lippincott, Philadelphia, 1931

Rackham's intricate play of colours can be seen on the bedspread. This later example of his work displays an extraordinary use of the Golden Age printing technique that made him famous.

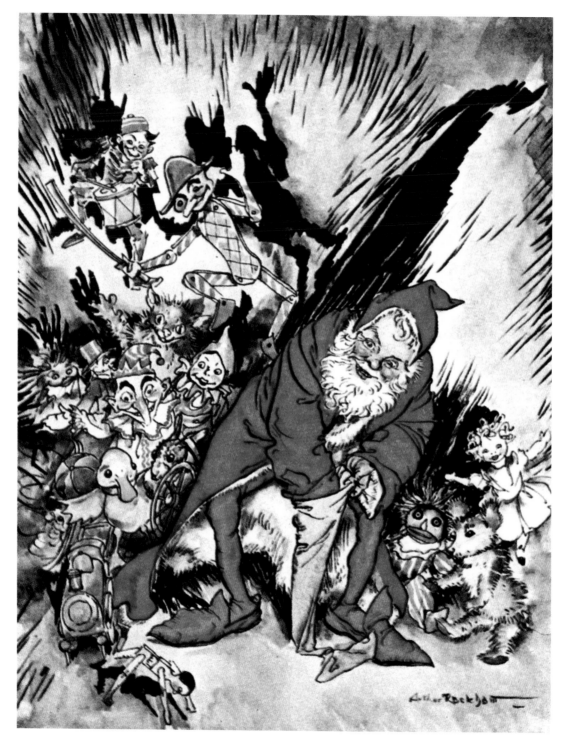

Filled all the stockings
Clement Moore, *The Night Before Christmas*
• J. B. Lippincott, Philadelphia, 1931

The shadows behind the toys bring them to life in this classic poem, the limited edition of which sold out promptly and was very popular in America.

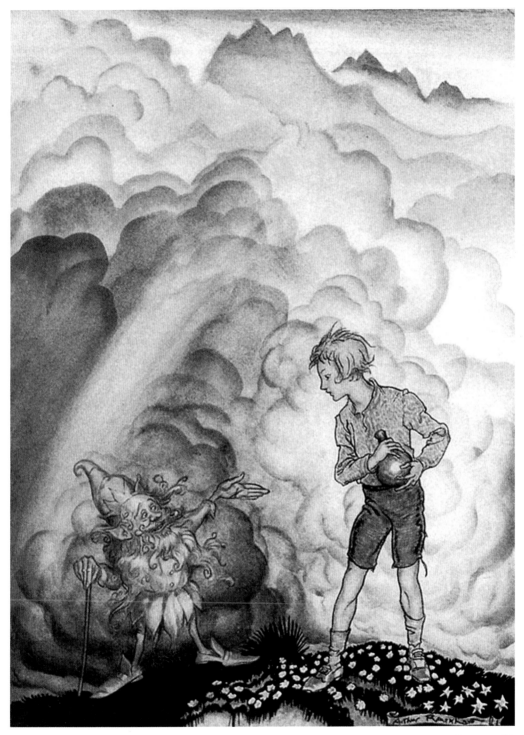

King of the Golden River

John Ruskin, *King of the Golden River*
• George Harrap & Co., London, 1932

Ruskin was a leading figure in defending fantasy art. He was an art critic, accomplished draughtsman and watercolourist, a thinker and a poet, who was also a champion of J.M.W. Turner and the Pre-Raphaelites.

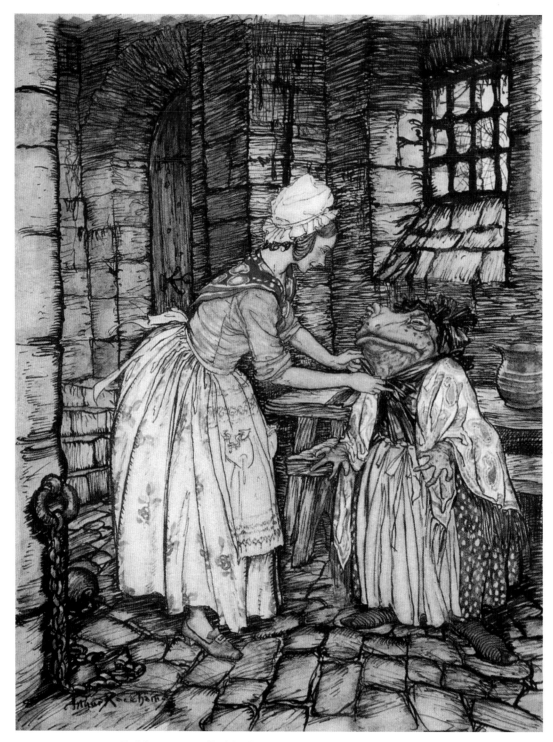

Toad dresses up

Kenneth Grahame, *Wind in the Willows*

• The Limited Editions Club, New York, 1940

Toad dressing up as a washer woman is a ruse to take revenge on 'the large woman'. Grahame's fantasy is an adept play between the city and the country.

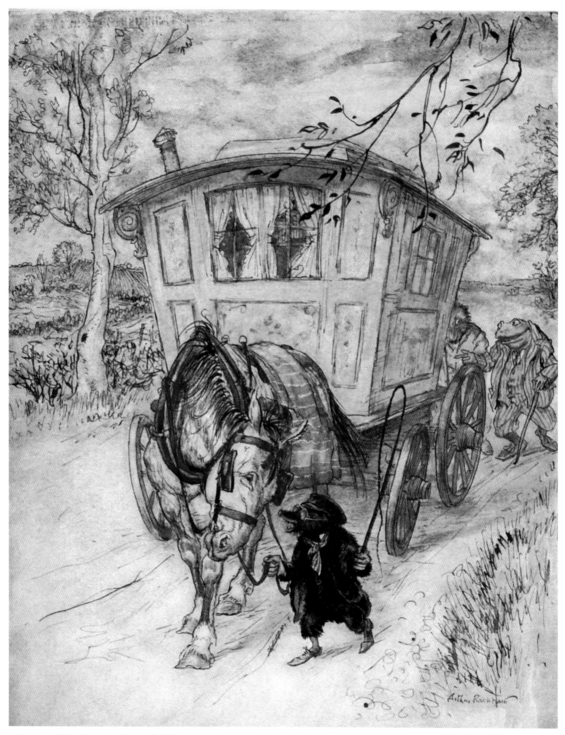

It was a golden afternoon, the smell of dust they kicked up was rich and satisfying
Kenneth Grahame, *Wind in the Willows*
• The Limited Editions Club, New York, 1940

One can imagine Rackham taking a country walk in the last year of his life, experiencing the simple things around him. Both the horse and Toad seem to personify the artist in front of and behind the slowly moving house.

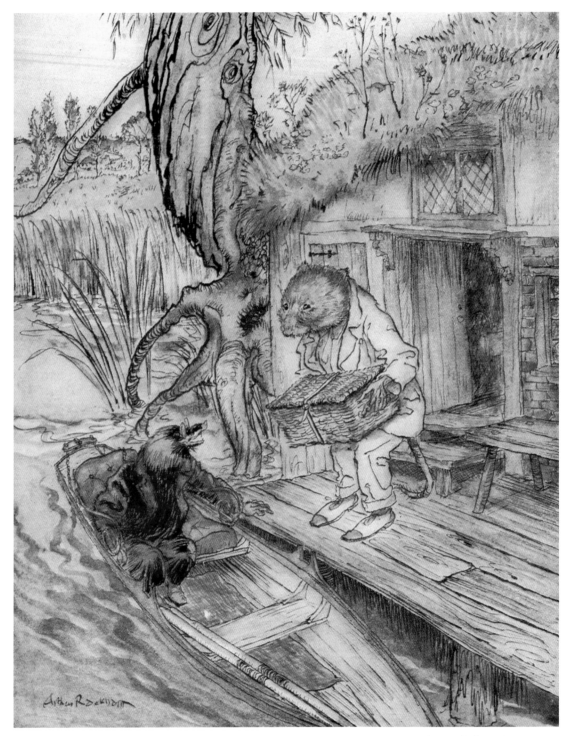

**Shove that under your feet he observed to the
mole, and he passed it down into the boat**
Kenneth Grahame, *Wind in the Willows*
• The Limited Editions Club, New York, 1940

Both Grahame and Rackham shared a nostalgic view of a peaceful England, its wealth derived
not merely from the great city of London but from the country where worlds of fantastic
imagination were born from its old roots in history.

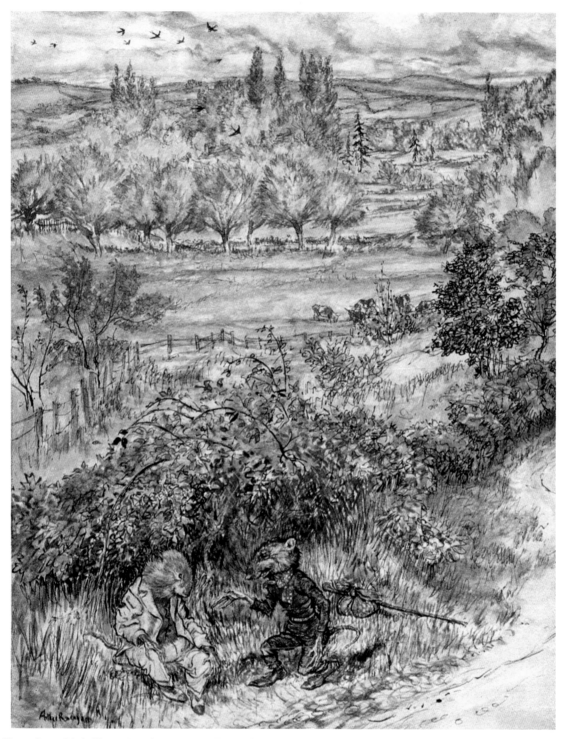

**The wayfarer saluted with a gesture of courtesy
that had something foreign about it**
Kenneth Grahame, *Wind in the Willows*
• The Limited Editions Club, New York, 1940

A typical Rackham composition with the main characters on the bottom ground of the painting with a country landscape dominating the rest of the picture, leaving little room for the sky. All rests upon the exchange between the two characters.

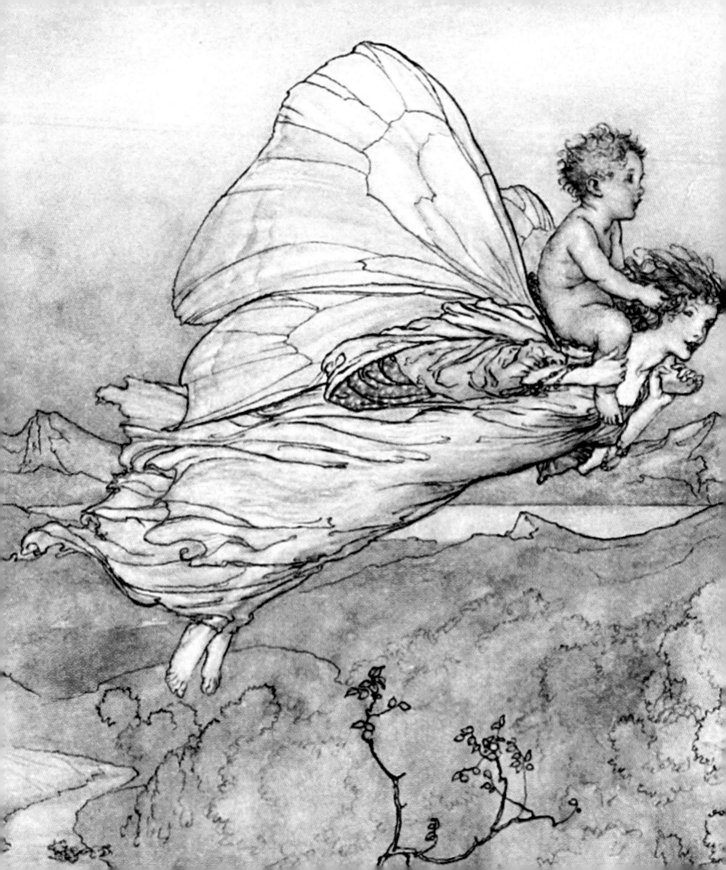

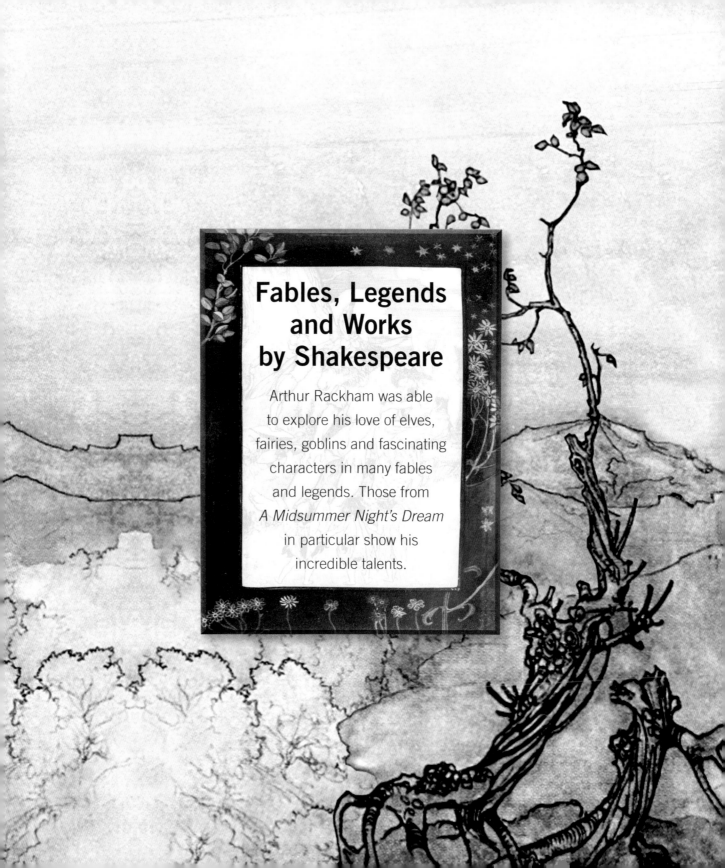

Fables, Legends and Works by Shakespeare

Arthur Rackham was able to explore his love of elves, fairies, goblins and fascinating characters in many fables and legends. Those from *A Midsummer Night's Dream* in particular show his incredible talents.

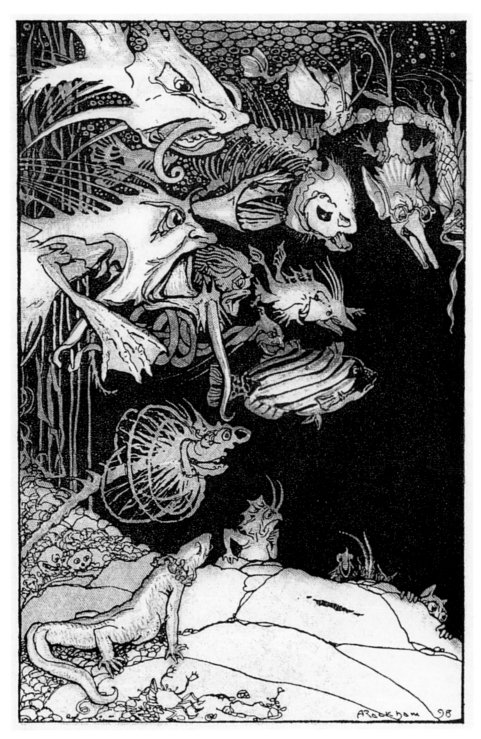

They'd such very odd heads and very odd tails
Thomas Ingoldsby, *The Ingoldsby Legends, or Mirth and Marvels*
• J. M. Dent & Co., London, 1898

'The Black Mousquetaire' is a poem reminding one of nineteenth-century English literature's fascination with Paris and the French language and its loose reputation regarding morality. This is followed by the poem, 'Sir Rupert the Fearless, A legend of Germany'.

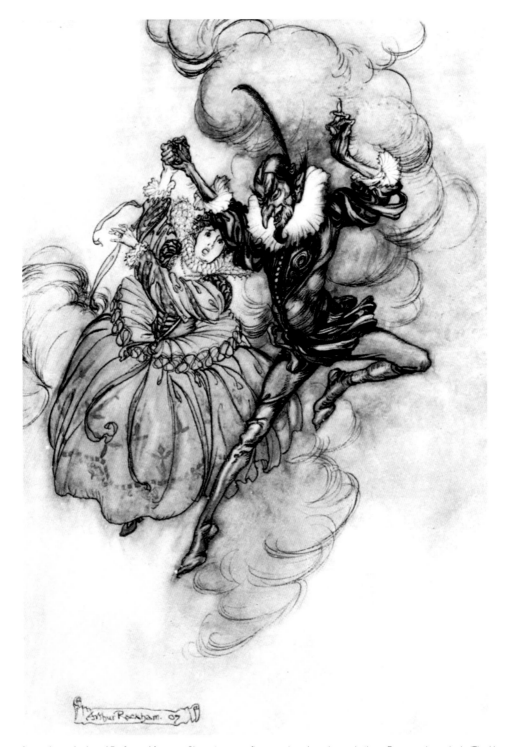

A grand pas de deux / Performed in the very first style by these two

Thomas Ingoldsby, *The Ingoldsby Legends, or Mirth and Marvels*
• J. M. Dent & Co., London, 1907

Characters are often swept or chased away in these European legends. In 'The House-Warming' the 'tall Figurant, ALL IN BLACK', prances in at midnight and courts the Dame of the House, Lady Alice, who is grasped by his 'horrid black claws'.

And the maids cried 'Good gracious, how very tenacious!'
Thomas Ingoldsby, *The Ingoldsby Legends, or Mirth and Marvels*
• J. M. Dent & Co., London, 1907

The mix of colour plates, styles, marginalia and line drawing are as eclectic as the texts in this rather neglected collection of tales. Rackham 'overhauled' many of these pictures for the 1907 version.

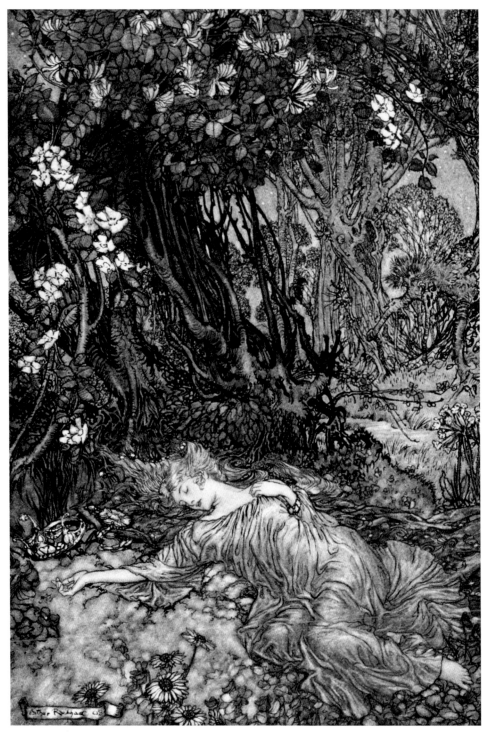

Frontispiece: Titania lying asleep
William Shakespeare, *A Midsummer Night's Dream,*
• William Heinemann, London, 1908

James Hamilton writes of Rackham that his 'interpretations of *A Midsummer Night's Dream* and *The Wind in the Willows*, for example, have become definitive, and continue to challenge later illustrators to find new approaches.'

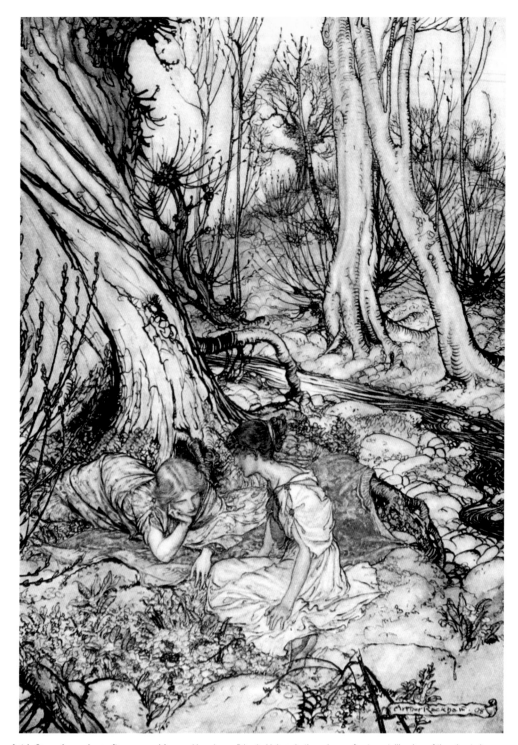

Act I, Scene I: … where often you and I,
Upon faint primrose-beds were wont to lie,
Emptying our bosoms of their counsel sweet

William Shakespeare, *A Midsummer Night's Dream*
• William Heinemann, London, 1908

Hermia confides in Helena in the privacy of nature, telling her of the plan to leave Athens behind with her beloved Lysander, thereby going against her father's wish that she wed Demetrius.

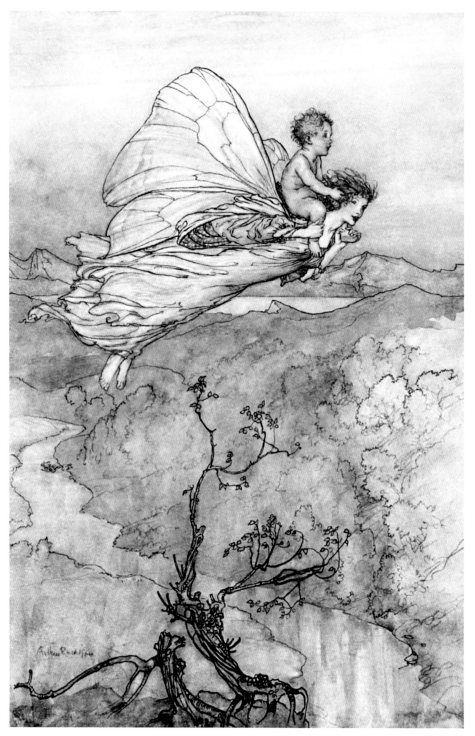

Act IV, Scene I: Welcome Good Robin. / See'st thou this sweet sight?
William Shakespeare, *A Midsummer Night's Dream*
• William Heinemann, London, 1908

In 1908, the *Daily Chronicle* wrote of Rackham, 'He is always at his best when his imagination has run free: he does not illustrate the play, he prefers to take an idea from the text and turn it into a Rackhamian picture …'

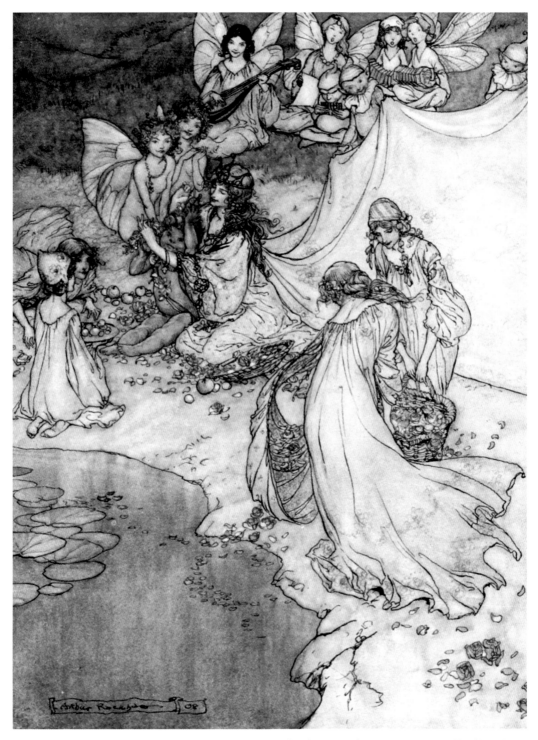

Act II, Scene I: She never had so sweet a changeling
William Shakespeare, *A Midsummer Night's Dream*
• William Heinemann, London, 1908

Gentle Puck, or Robin Goodfellow, has informed the spectator that King Oberon is angry at Titania for abducting the sweet boy from India. Puck, the King's mischievous jester is probably Rackham's favourite literary character.

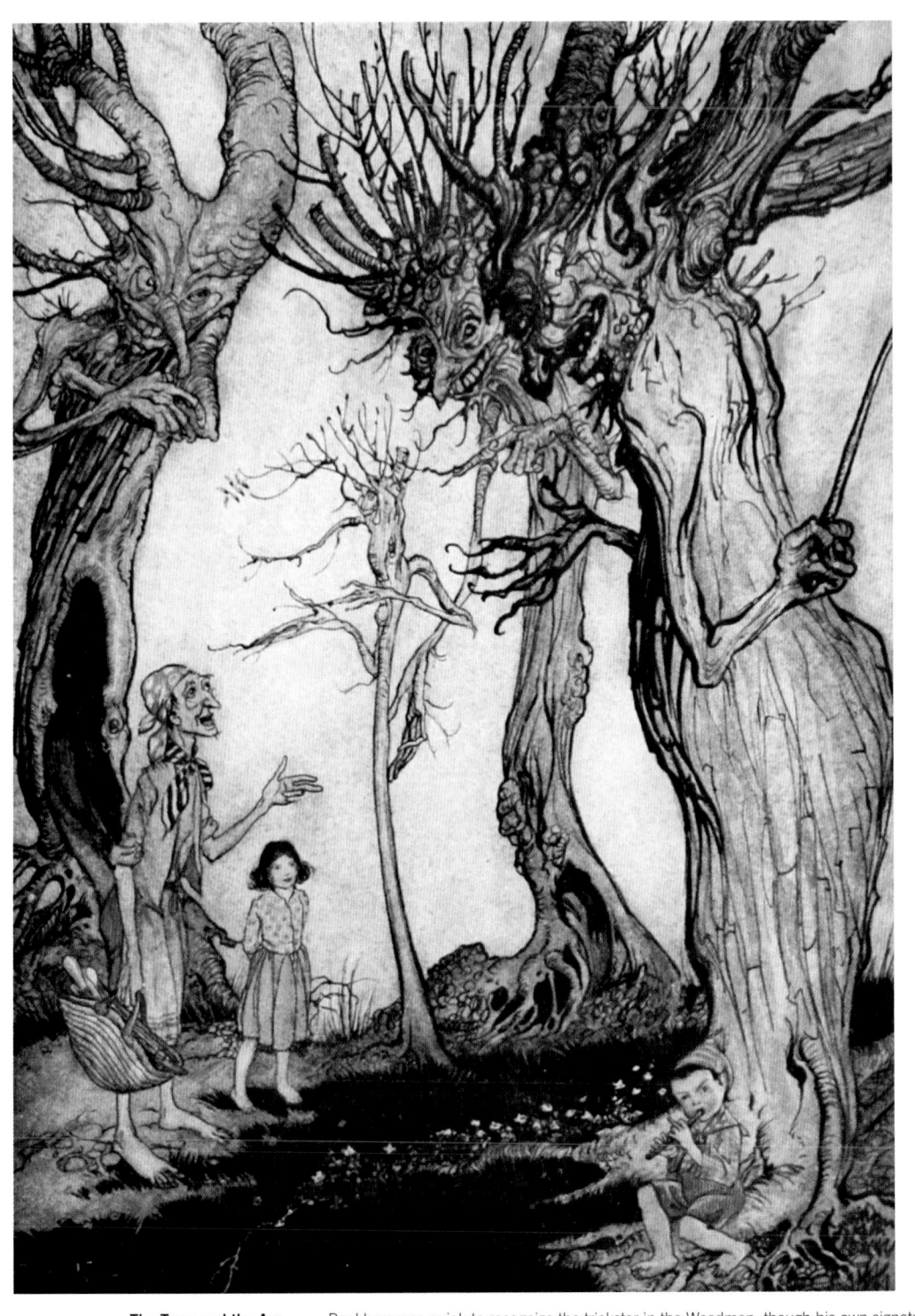

The Trees and the Axe
V.S. Vernon, *Aesop's Fables*
• Doubleday, Page & Co., New York, 1912

Rackham was quick to recognize the trickster in the Woodman, though his own signature 'principal trees' would never fall for such a ruse. It is hard not to imagine one of Rackham's trees whenever his name is mentioned.

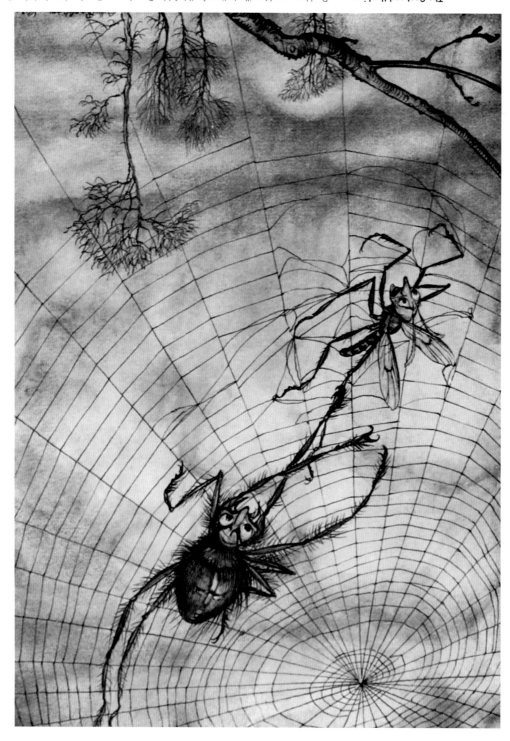

The Gnat and the Lion

V.S. Vernon, Aesop's Fables
- Doubleday, Page & Co., New York, 1912

Rackham used two illustrations for this fable. One above, a line drawing, depicting the gnat taunting the lion; the other below, in colour, the illustration one sees here, with the same gnat. A fable told in two pictures.

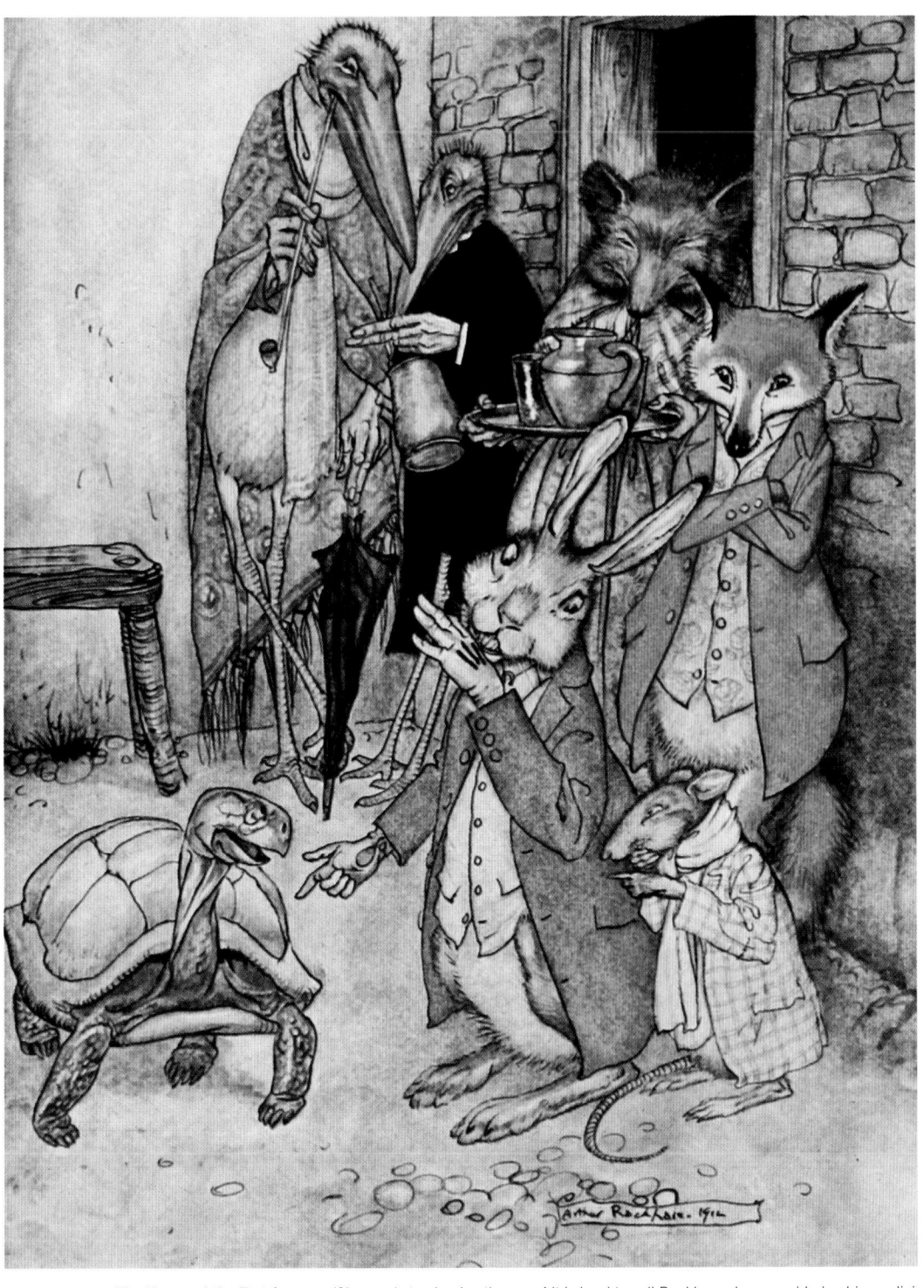

The Hare and the Tortoise
V.S. Vernon, *Aesop's Fables*,
• Doubleday, Page & Co., New York, 1912

'Slow and steady wins the race.' It is hard to call Rackham slow, considering his prodigious output, but there is no doubt that he left many an illustrator and artist behind by simple 'plodding on'.

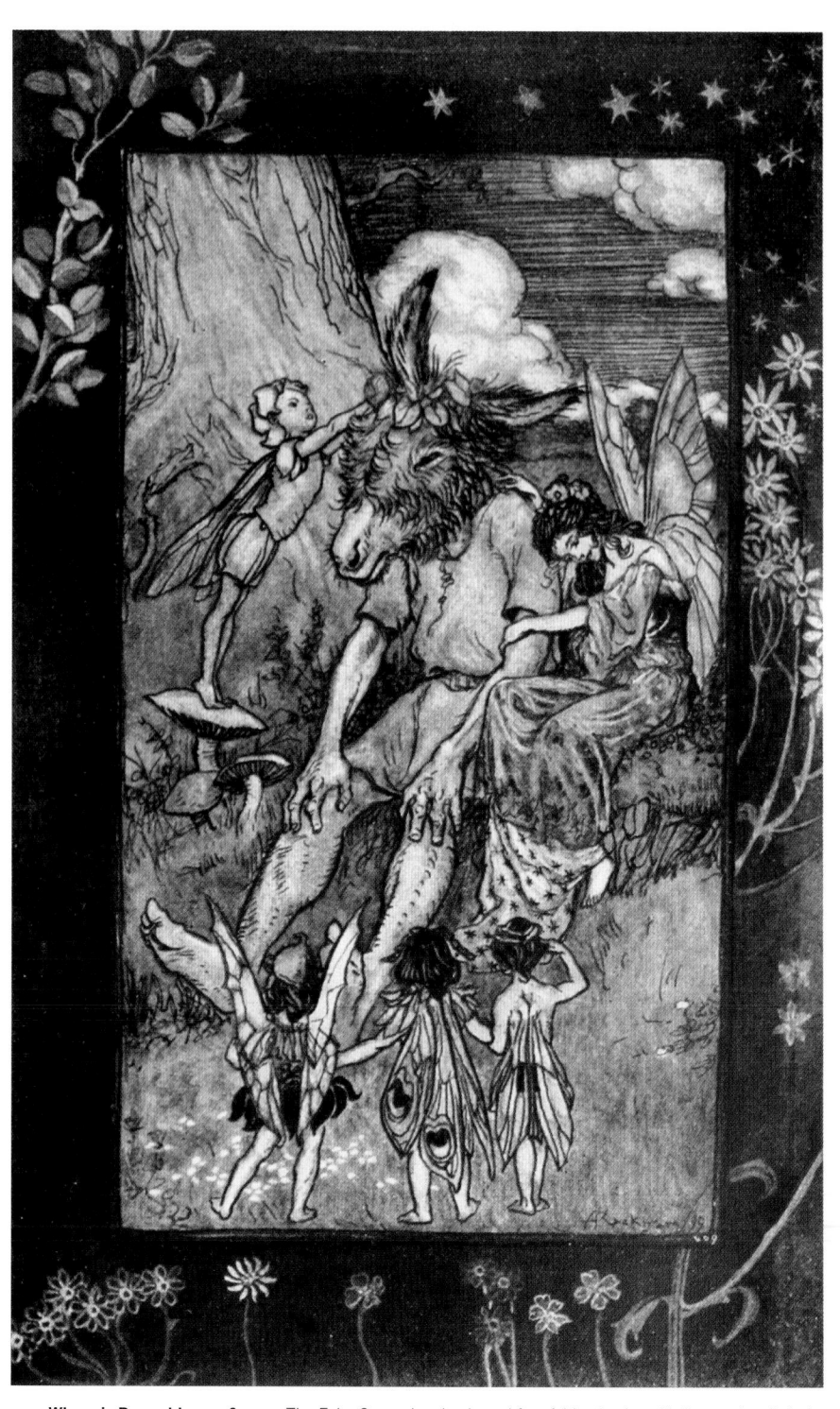

Where is Pease-blossom?
Charles and Mary Lamb, *Tales from Shakespeare*
• Temple Press, London, 1909

The Fairy Queen has beckoned four fairies to play with the ass-headed clown, her 'new favourite'. She is soon found out by Oberon who mocks her, demanding the Changeling. The ornamental frame as border is uncharacteristic of Rackham.

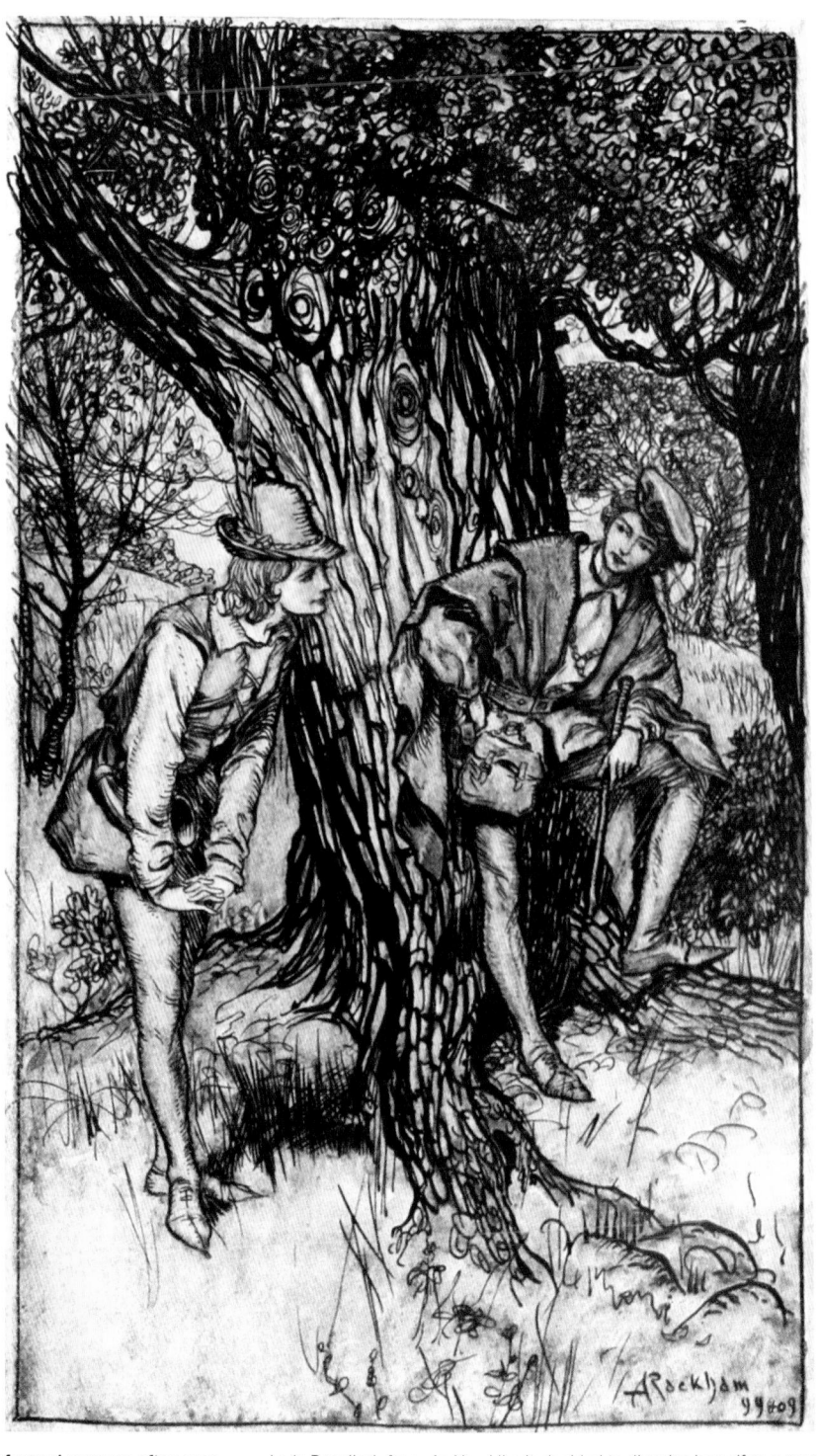

Ganymede assumed the forward manners often seen in youths when they are between boys and men

Charles and Mary Lamb, *Tales from Shakespeare*
• Temple Press, London, 1909

Lady Rosalind, from *As You Like It,* decided to disguise herself as a man after her friend Celia suggested they should dress as country maids. Rackham takes very 'forward manners' in making Rosalind look particularly masculine.

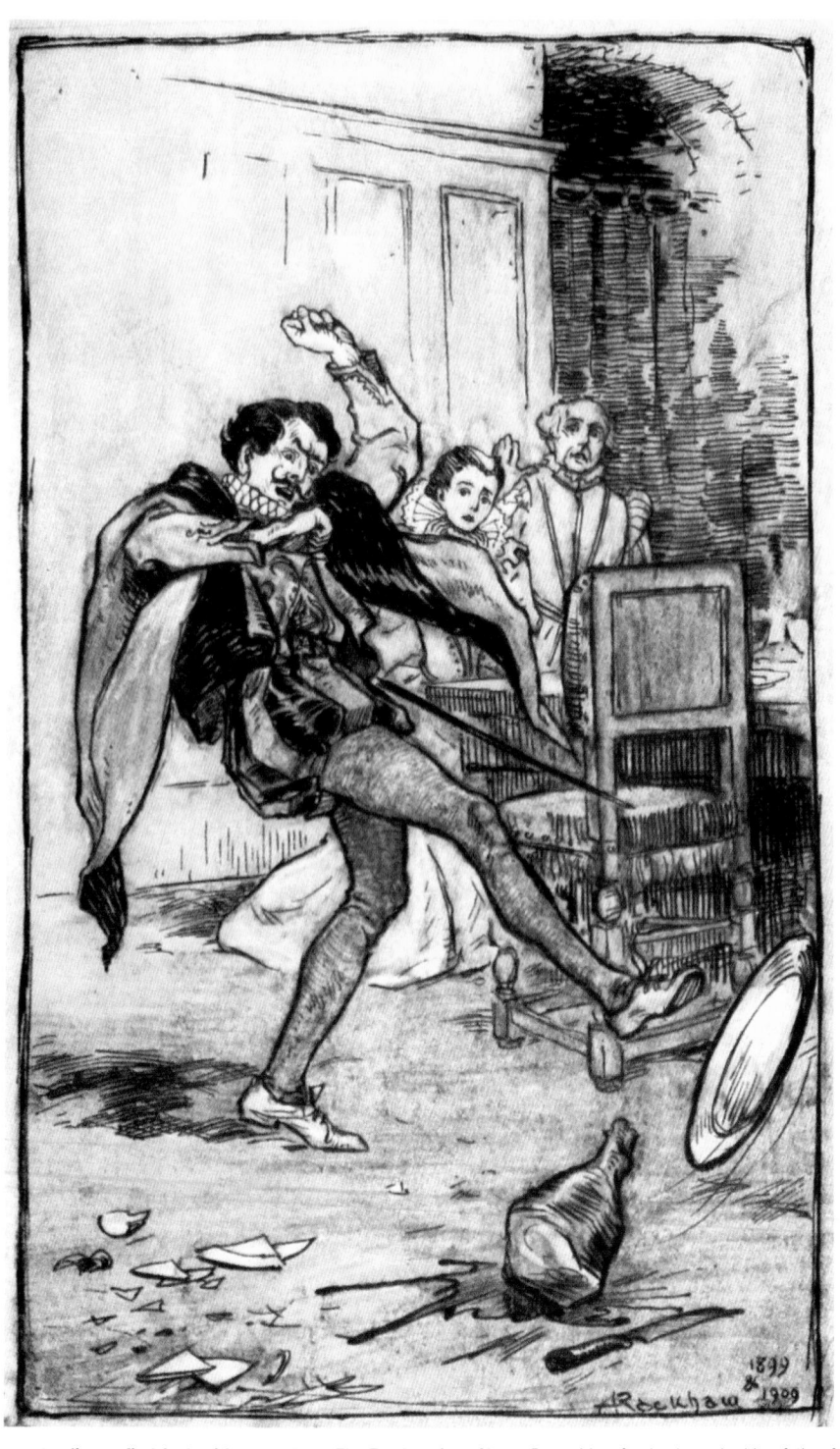

**Petruchio, pretending to find fault with
every dish, threw meat about the floor**
Charles and Mary Lamb, *Tales from Shakespeare*
• Temple Press, London, 1909

From *The Taming of the Shrew*, Petruchio, after having asked her father for the
hand of Katharine, the Shrew, was determined to marry the recalcitrant Lady.

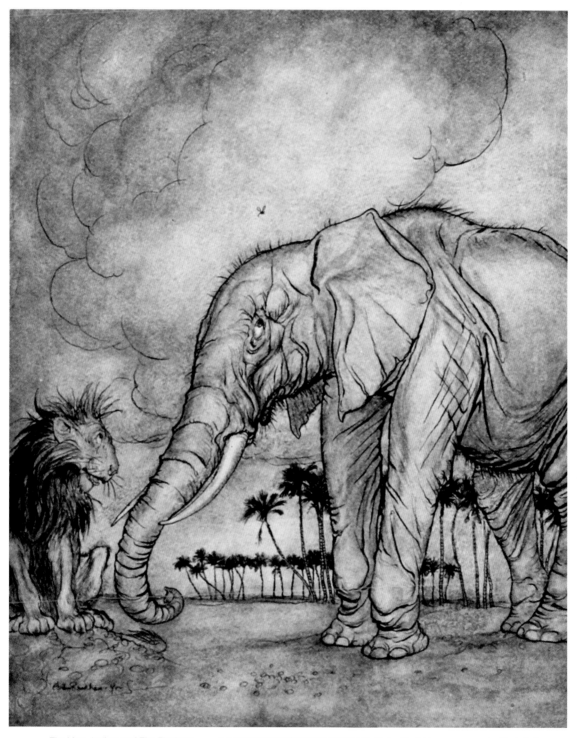

The Lion, Jupiter, and The Elephant
V.S. Vernon, *Aesop's Fables*
• Doubleday, Page & Co., New York, 1912

It is assumed that Rackham was free to choose the fables or passages he illustrated. Here, the scene appears to be for pictorial and compositional reasons, another example of Rackham's subtle use of colour and occupation of space.

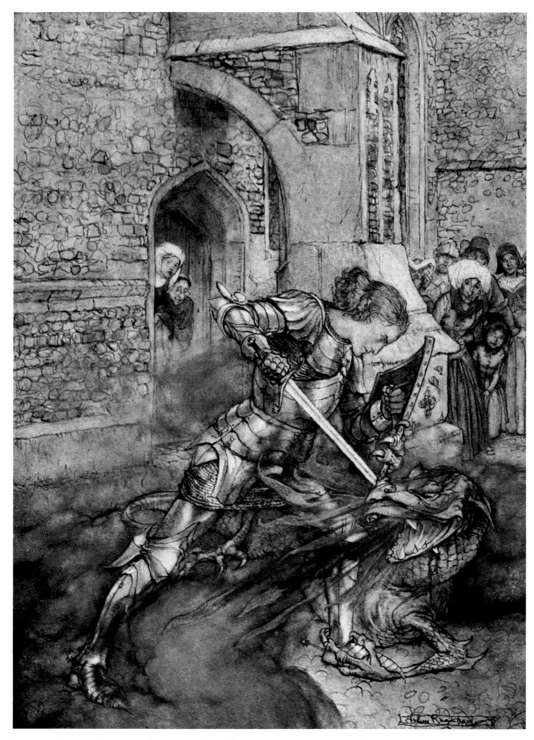

How Sir Launcelot fought with a friendly dragon
Alfred W. Pollard, *The Romance of King Arthur and his Knights of the Round Table* • Macmillan and Co., London, 1917

This edition was published during the First World War and no doubt was in part meant to raise Britain's sense of strength and courage. Rackham fulfilled his duty with zeal and was much appreciated by soldiers and fellow patriots.

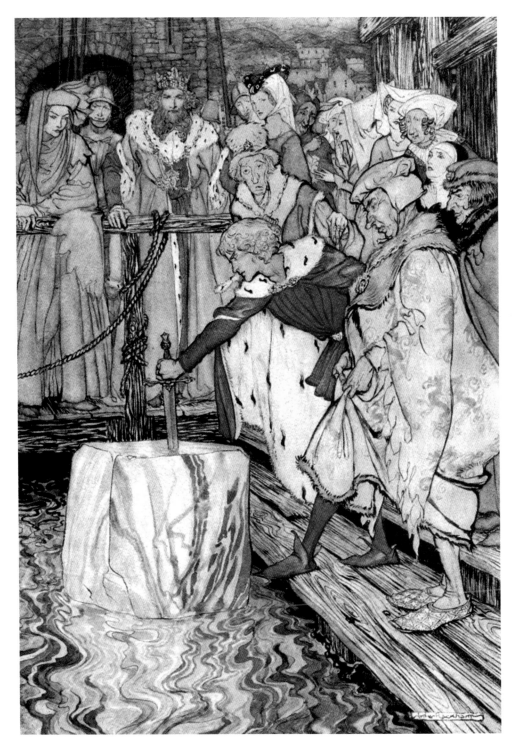

How Galahad drew out the sword from the floating stone at Camelot

Alfred W. Pollard, *The Romance of King Arthur and his Knights of the Round Table* • Macmillan and Co., London, 1917

No body of fantasy work with the breadth, and depth, of Rackham's would be complete without covering the legend of King Arthur. These stories still continue to inspire works in all genres of art and literature.

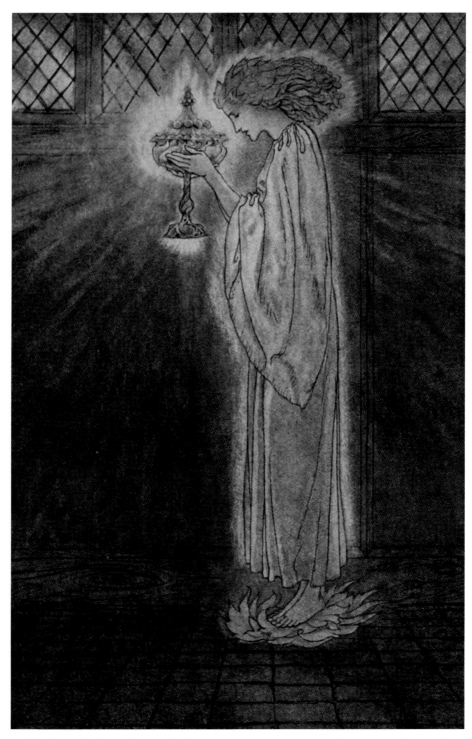

How at the Castle of Corbin a maiden bare in the Sangreal and foretold the achievements of Galahad

Alfred W. Pollard, *The Romance of King Arthur and his Knights of the Round Table* • Macmillan and Co., London, 1917

Rackham was indebted to, or rather rendered homage to, and 'borrowed' quite freely from Aubrey Beardsley for the overall composition of this edition. The Sangreal is the Holy Grail, a vessel representing divine inspiration.

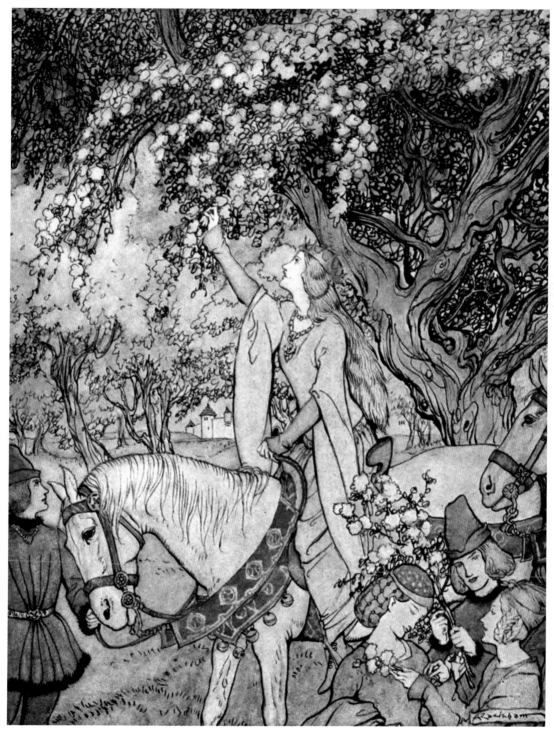

**How Queen Guenever rode a-Maying into
the woods and fields beside Westminster**

Alfred W. Pollard, *The Romance of King Arthur and his Knights
of the Round Table* • Macmillan and Co., London, 1917

Rackham's sense of significant composition places the Queen in the centre of the image as her attendants keep to themselves in the lower right corner. One sees the full mastery of the artist's colouration and representation of the English countryside.

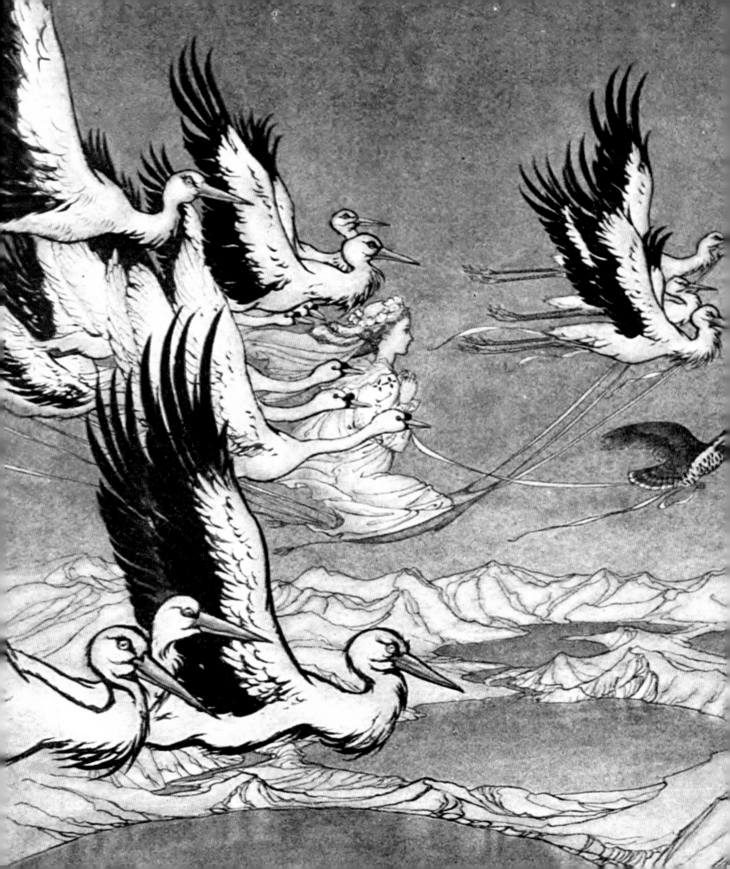

Operas
and Poetry

During the Golden Age of
Illustration there was a
growing market for highly
luxurious, limited editions
of books, particularly for
those containing high art
such as opera and poetry.

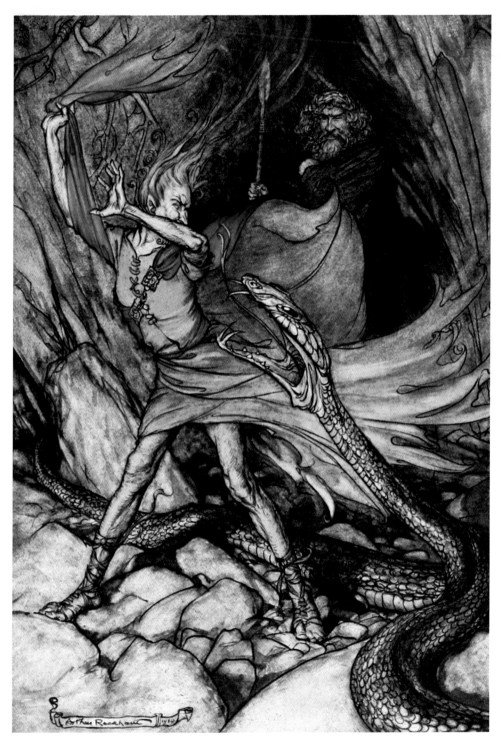

Ohé! Ohé! / Horrible dragon, / O swallow me not! / Spare the life of poor Loge!

Richard Wagner, Translated by Margaret Armour, *The Rhinegold and The Valkyrie* • Doubleday, Page & Co., New York, 1910

The strident tempo and rise and fall of Wagner's 'Ring' is captured throughout Rackham's illustrations through his use of bright colours and suggestions of sharp, quick movements.

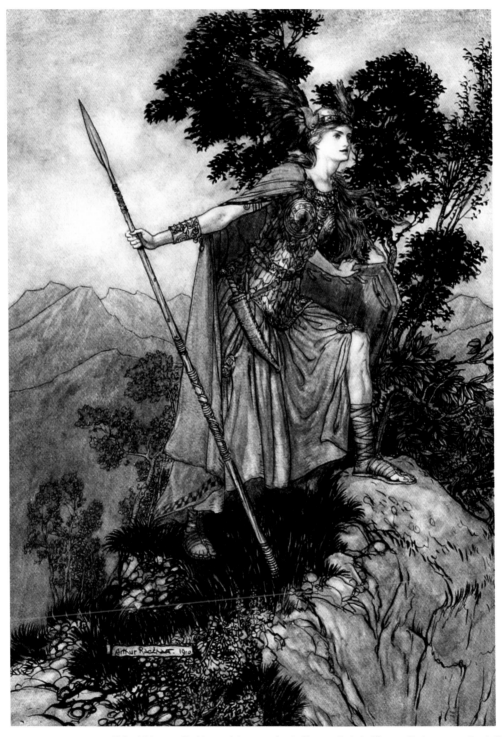

Brünnhilde
Richard Wagner, Translated by Margaret Armour, *The Rhinegold
and The Valkyrie* • Doubleday, Page & Co., New York, 1910

Rackham paints a very classic, Norse mythological figure with strong masculine traits.
She was in love with the 'Ring' hero Siegfried and is the daughter of Wotan with Erda,
an earth goddess.

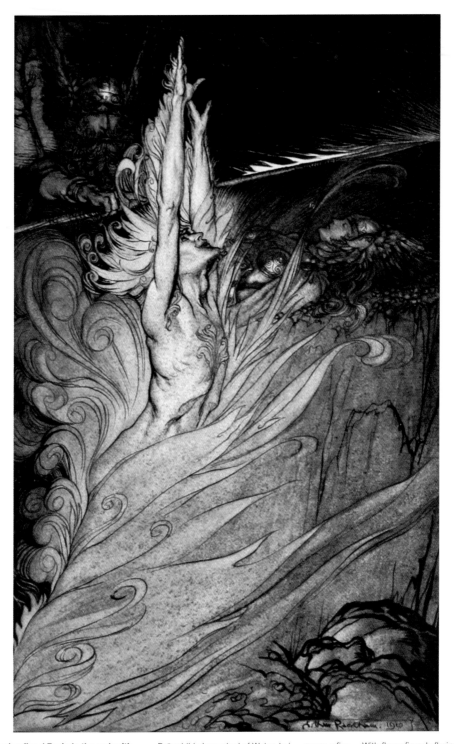

Appear, flickering fire, / Encircle the rock with thy flame! / Loge! Loge! Appear!

Richard Wagner, Translated by Margaret Armour, *The Rhinegold and The Valkyrie* • Doubleday, Page & Co., New York, 1910

Brünnhilde has asked of Wotan to ' … cause a fire … With flame fiercely flaring / Girdle the rock … And may its tongue lick … The coward who, daring, rashly / Approaches the terrible spot!'

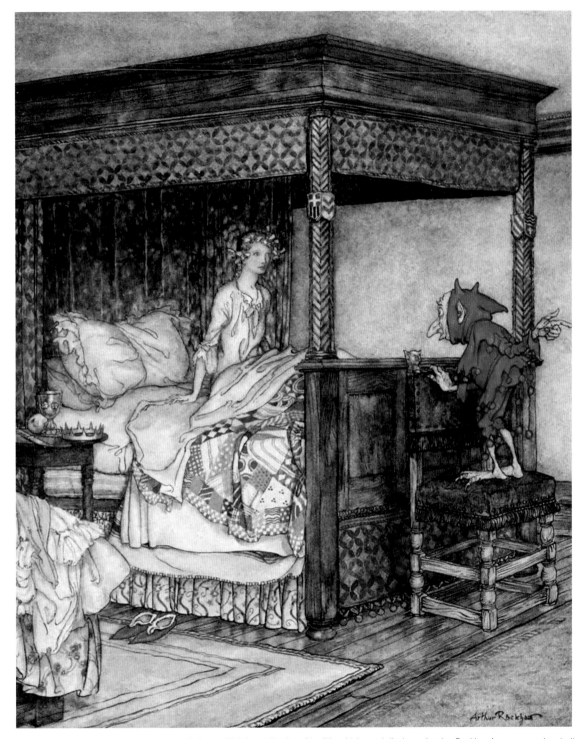

O waken, waken, burd Isbel
Some British Ballads
• Dodd Mead & Co., New York, 1919

This is a collection of traditional tales and displays, showing Rackham's pronounced maturity in an aspect of composition – densely packed book-size images – that is rarely portrayed with such charm and lightness.

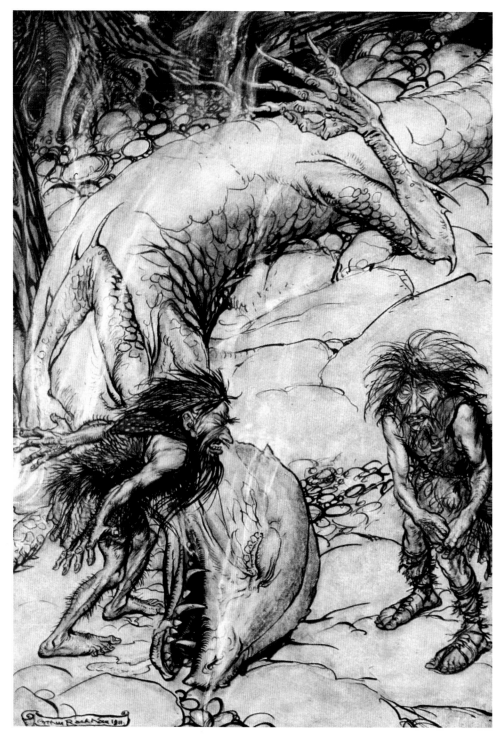

The dwarfs quarrelling over the body of Fafner
• Richard Wagner, Translated by Margaret Armour, *Siegfried and the Twilight of the Gods* • William Heinemann, London, 1911

As a schoolboy, the great novelist C.S. Lewis, had a passion for Rackham's 'Ring' illustrations, particularly Siegfried. He later wrote, 'His pictures … seemed to me to be the very music [of Wagner] made visible.'

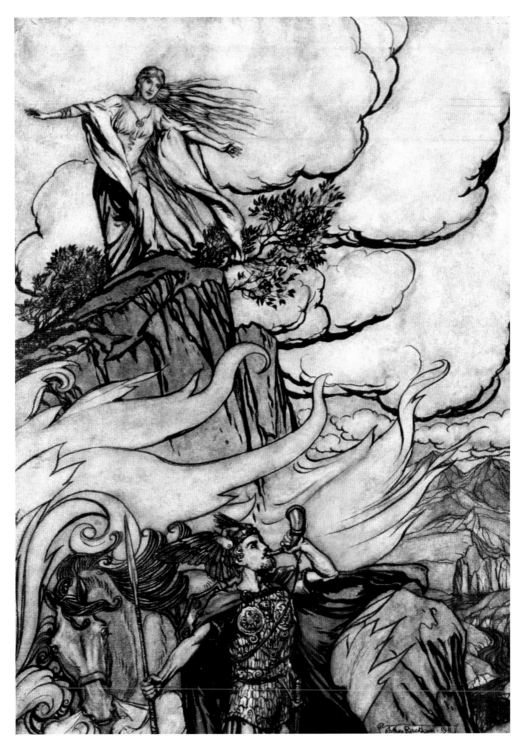

Siegfried leaves Brünnhilde in search of adventure
Richard Wagner, Translated by Margaret Armour, *Siegfried and the Twilight of the Gods* • William Heinemann, London, 1911

Critical acclaim at the time of the book's release suggested that Rackham had 'entered into competition' with some of the greatest stage performances of the 'Ring' up to that time.

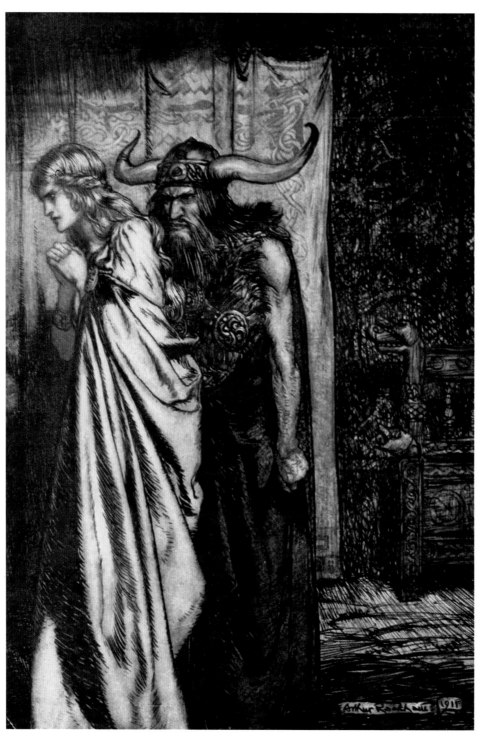

O wife betrayed / I will avenge / Thy trust deceived
Richard Wagner, Translated by Margaret Armour, *Siegfried and the Twilight of the Gods* • William Heinemann, London, 1911

Hagen is a psychopath who wants to control the ring and its powers, and have his half brother marry Brünnhilde. He has Siegfried murdered, betraying Brünnhilde's confidence in him. She burns herself and Siegfried, and urges Loge to burn Valhalla.

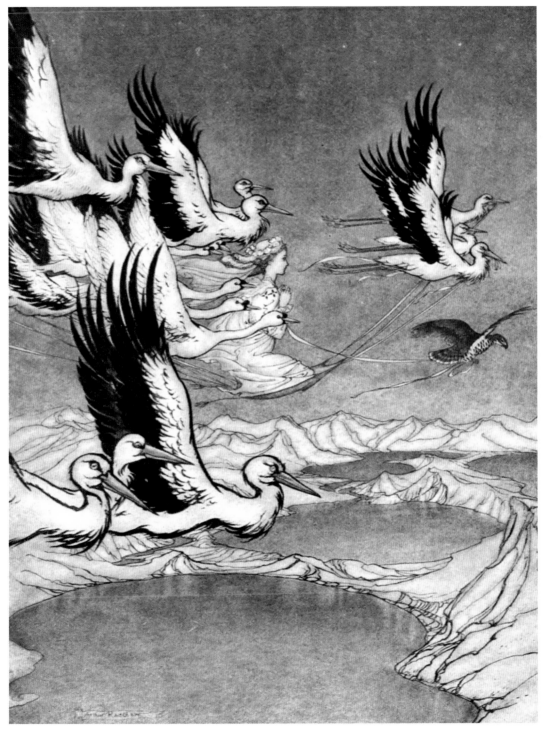

Earl Mar's daughter
Some British Ballads
• Dodd Mead & Co., New York, 1919

The story of a young woman and a dove, it turns into a man at night and has seven sons by her. The Earl tries to kill the dove but it returns with an army of birds to reclaim its beloved.

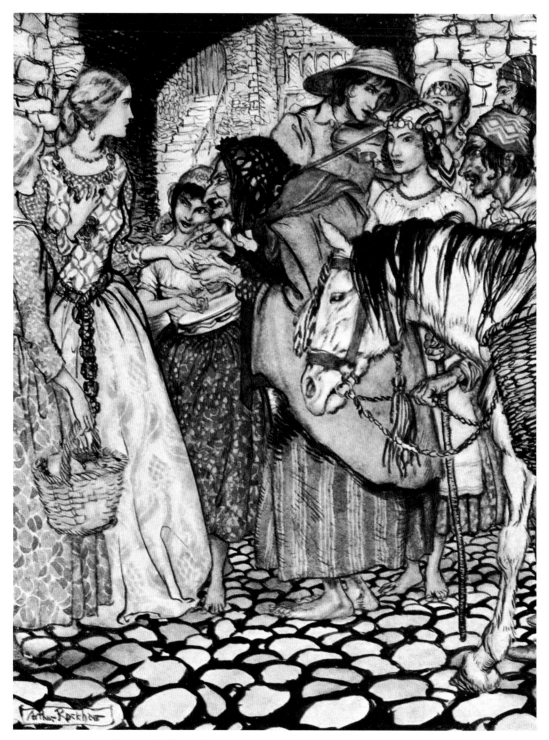

The gypsy laddie
Some British Ballads
• Dodd Mead & Co., New York, 1919

Rackham loads this picture with colour and people. The tone is strikingly realist. The ballad tells a story of gypsies who woo a lady away from her lord. She prefers their company over his riches.

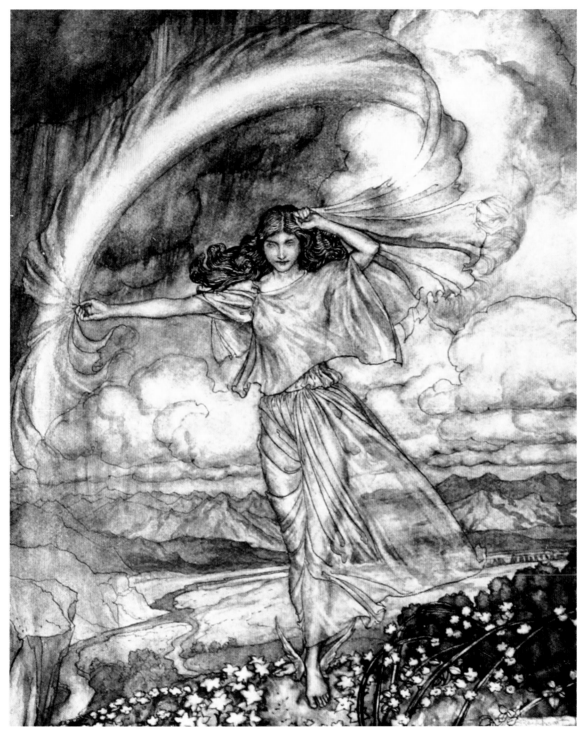

Iris there, with humid bow

John Milton, *Comus*

• William Heinemann, London, 1921

In 1891 edition, William Bell writes that, 'Few poems have been more variously designated [criticized] than *Comus*. Milton himself describes it simply as "A Mask" …' It is certainly as eclectic in style as are Rackham's illustrations.

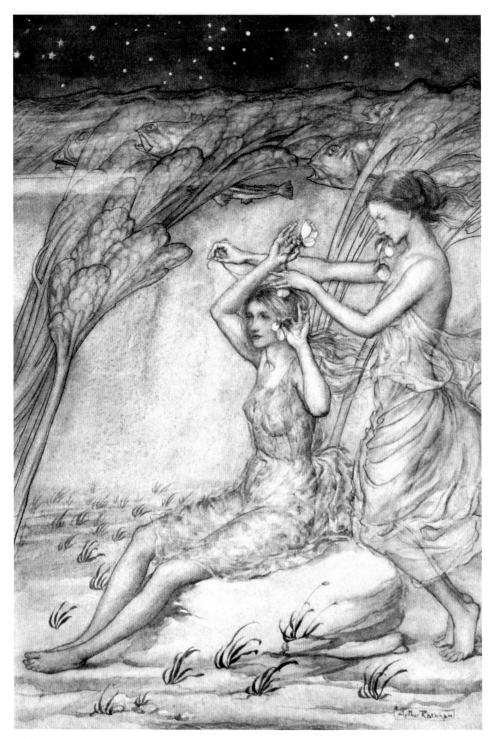

Sabrina fair / Listen where thou art sitting
John Milton, *Comus*
• William Heinemann, London, 1921

There is little question that Rackham used live models for this book's illustrations, including this 'Song', which Milton addressed to 'the Goddess of the silver lake' asking her to 'Listen, and save!'

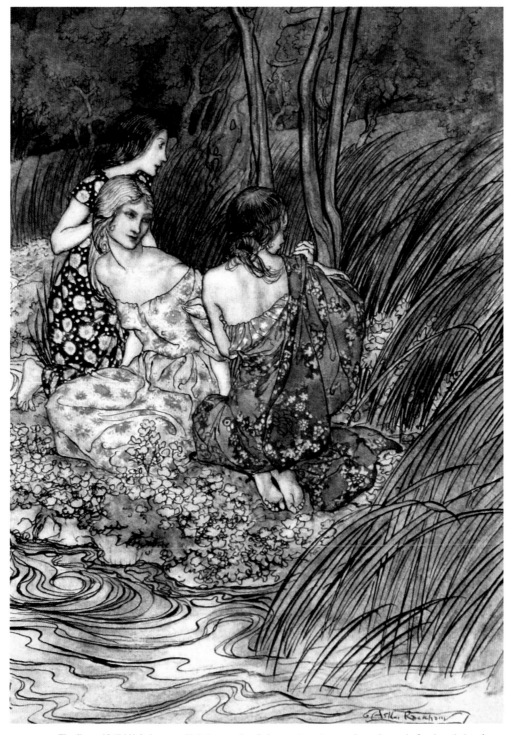

The flowry-kirtl'd Naiades
John Milton, *Comus*
• William Heinemann, London, 1921

Naiades were hardly innocent creatures and were known in Greek mythology for drowning young men who fell prey to their charms. They were meant to give life to rivers, lakes, springs and fountains.

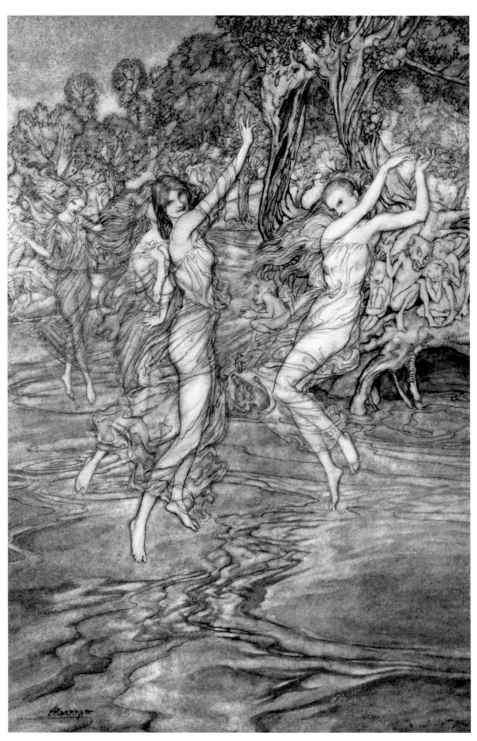

**By all the Nymphs that nightly dance /
Upon the streams with wily glance**

John Milton, *Comus* • William Heinemann, London, 1921

The Nymphs are fully aware of being watched and coveted by the odd goblins on the shore. Rackham increasingly perfected his demi-nudes, transparent veils and wraps, particularly in *Comus*.

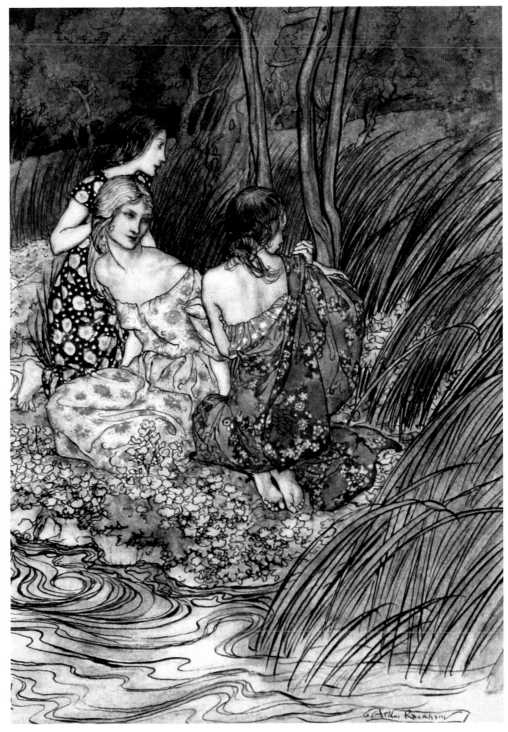

The flowry-kirtl'd Naiades
John Milton, *Comus*
• William Heinemann, London, 1921

Naiades were hardly innocent creatures and were known in Greek mythology for drowning young men who fell prey to their charms. They were meant to give life to rivers, lakes, springs and fountains.

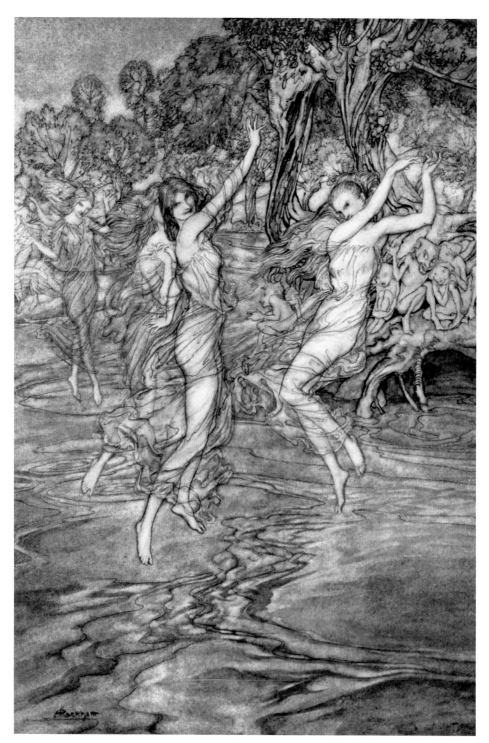

**By all the Nymphs that nightly dance /
Upon the streams with wily glance**

John Milton, *Comus* • William Heinemann, London, 1921

The Nymphs are fully aware of being watched and coveted by the odd goblins on the shore. Rackham increasingly perfected his demi-nudes, transparent veils and wraps, particularly in *Comus*.

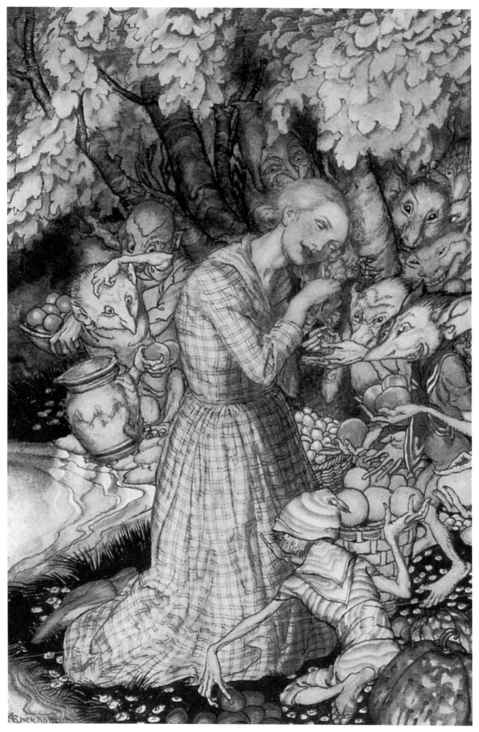

Frontispiece: She clipped a precious golden lock
Christina Rossetti, *Goblin Market*
• George G. Harrap & Co., London, 1933

The poet was the sister of Dante Gabriel Rossetti who, as poet and artist, was a founding member of the Pre-Raphaelite Brotherhood. This book is charged with sexual and inebriating double meanings.

Novels and Short Stories

The depth and scope of
Arthur Rackham's illustrative
powers never waiver and are
particularly present in his
illustrations for commercially
successful novels that often
explore Victorian themes, such
as *A Christmas Carol*.

'Equipped in a pair of his father's cast-off galligaskins, which he had as much ado to hold up as a fine lady does her train in bad weather'

Washington Irving, *Rip Van Winkle* • William Heinemann, London, 1905

'Rip' was Rackham's first popular success and helped propel the American short story, and its author, into worldwide recognition. It also resulted in a lasting relationship with the publishing house William Heinemann.

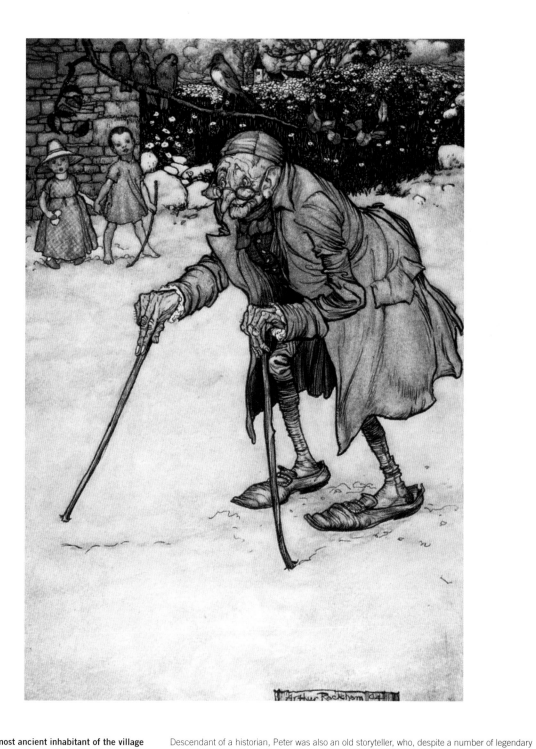

Peter was the most ancient inhabitant of the village
Washington Irving, *Rip Van Winkle*
• William Heinemann, London, 1905

Descendant of a historian, Peter was also an old storyteller, who, despite a number of legendary elements in his telling, convinced townsfolk that this Old Rip was the younger Rip they once knew.

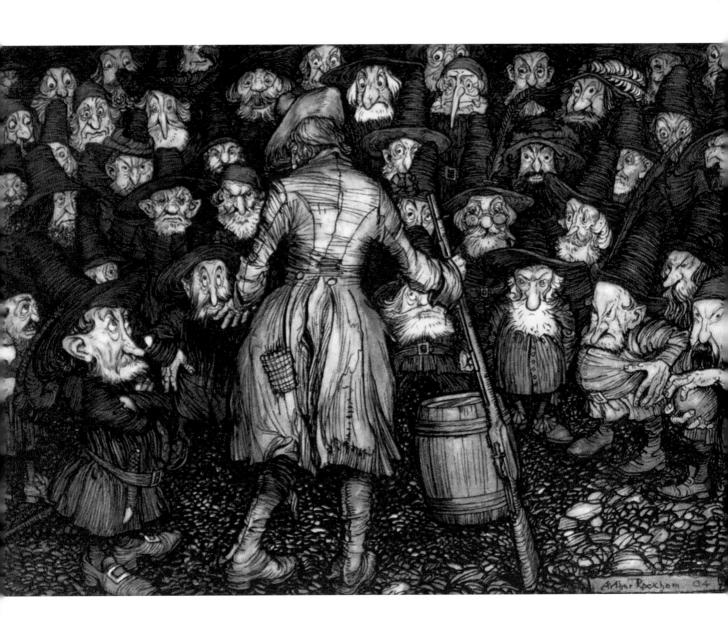

**'They stared at him with such fixed, statue-like gaze, that his
heart turned within him and his knees smote together'**
Washington Irving, *Rip Van Winkle* • William Heinemann, London, 1905

Rackham astutely gives the impression that absolutely everyone in town is watching Old Rip by
filling the frame with bodies and faces alone. Seeing their sceptical gazes and Rip from behind
reinforces a sense that a judgement is being rendered.

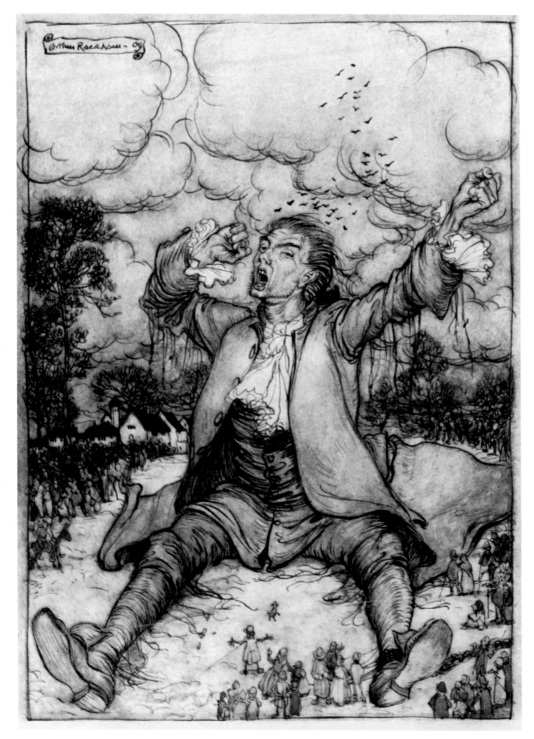

**Gulliver Released from the Strings
Raises and Stretches Himself**
Jonathan Swift, *Gulliver's Travels* • E.P. Dutton, London, 1909

Rackham was not much of a Gulliver regarding family life, but he was a quintessential travelling Englishman. Swift's satirical fantasy is full of jabs at the follies of humanity, much like many of Rackham's illustrations.

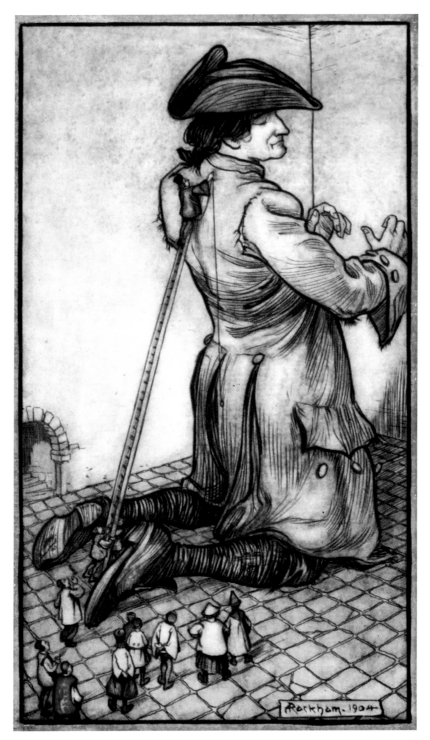

**The Lilliputian tailors measure Gulliver
for a new suit of clothes**

Jonathan Swift, *Gulliver's Travels* • E.P. Dutton, London, 1909

This 1909 reprint was released in both trade and deluxe editions in which 'Old drawings [are] altered … overhauled' versions of Rackham's earlier illustrations from 1900. He would often say 'a very little can go a long way'.

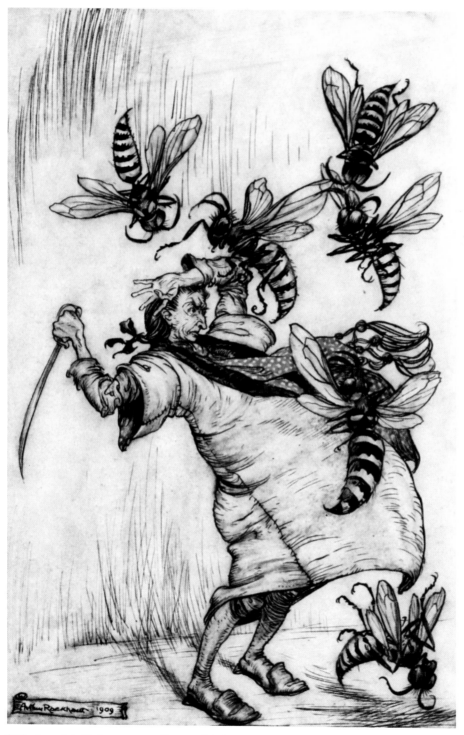

Gulliver's combat with the wasps

Jonathan Swift, *Gulliver's Travels*
• E.P. Dutton, London, 1909

There was little in the way of imaginative invention for Rackham to do but to follow Swift's lead, which the artist does most faithfully. His compositions are posed and the illustrations tend to enhance as opposed to extend the text.

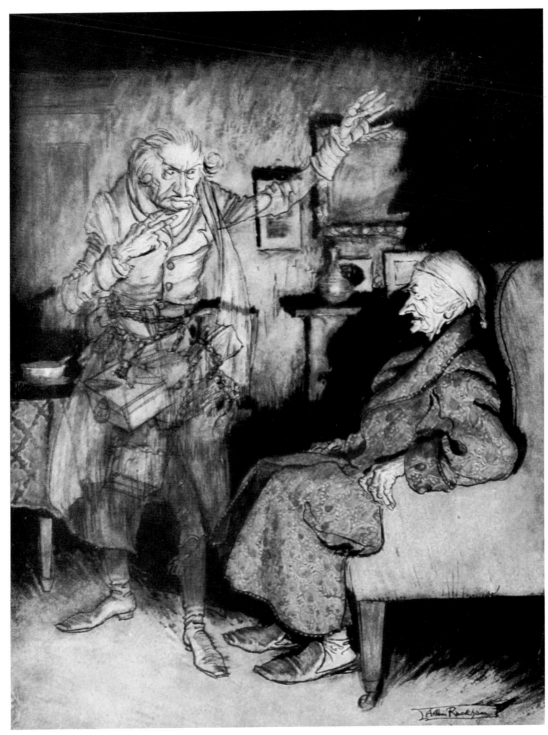

'How now?' said Scrooge, caustic and cold as ever

Charles Dickens, *A Christmas Carol*
• William Heinemann, London, 1915

One senses there may have been more than a touch of Dicken's celebrated Scrooge in Rackham's father. In modern terms, he would likely have been a fiscal conservative with a likeable character.

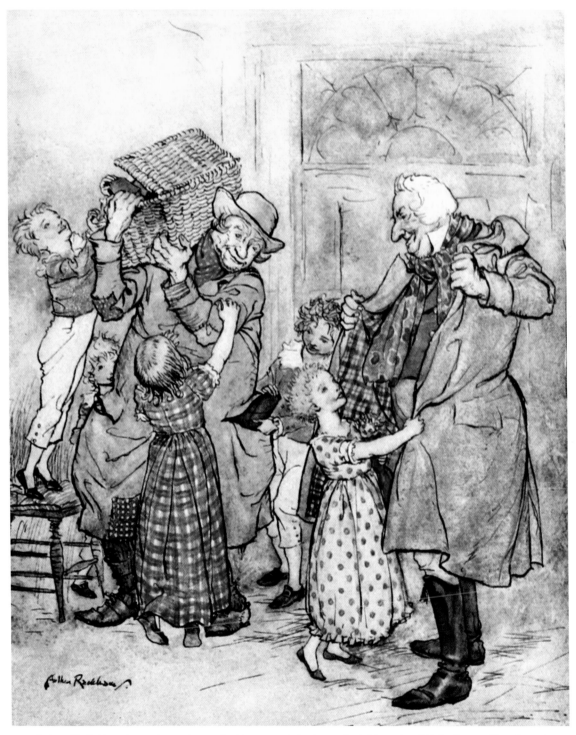

Laden with Christmas toys and presents
Charles Dickens, *A Christmas Carol*
• William Heinemann, London, 1915

Rackham concentrates here on the boisterous joy of this family scene. The colours of the dress and lively informal movement of the characters unashamedly underline the gaiety of a real home.

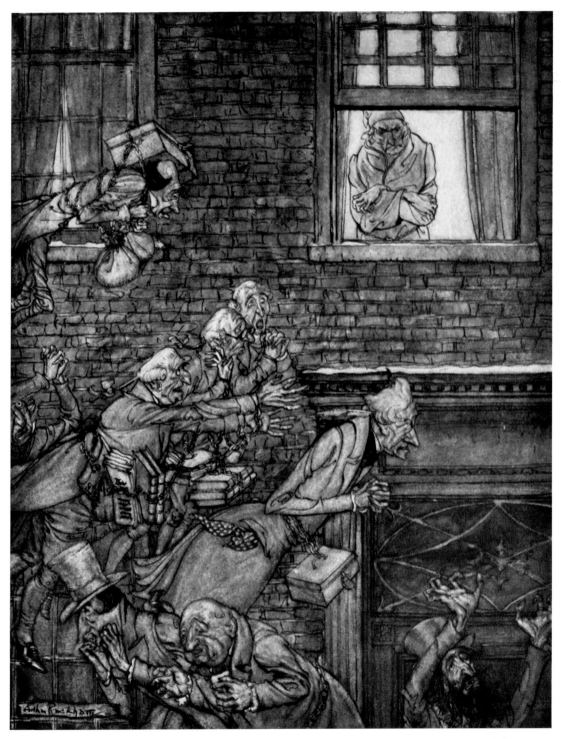

**The air was filled with phantoms,
wandering hither and thither**

Charles Dickens, *A Christmas Carol*
• William Heinemann, London, 1915

Scrooge's passion was meant to make a believer out of him and to repent before it was too late to save his soul. Rackham would have been keenly aware of the religious, not merely fantasy, elements of this passage.

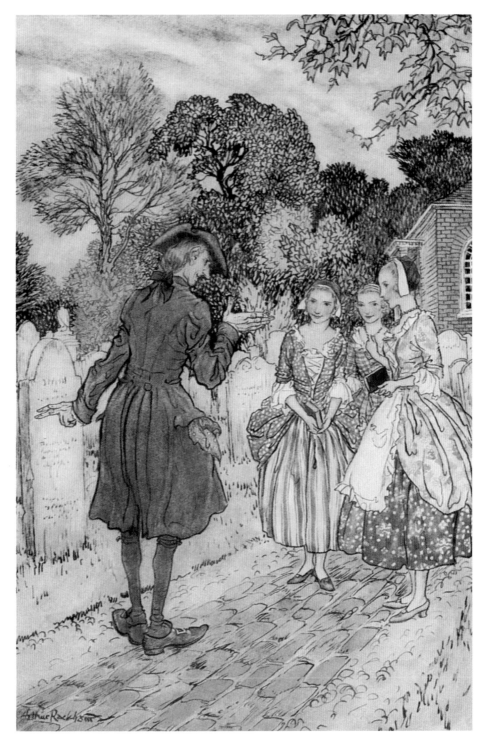

Ichabod talking to girls
Washington Irving, *The Legend of Sleepy Hollow*
• George G. Harrap & Co., London, 1928

Rackham would have been aware of conventions of popular romance literature at the time, which Irving was clearing satirising. Ichabod was far less interested in love than in wealth and food.

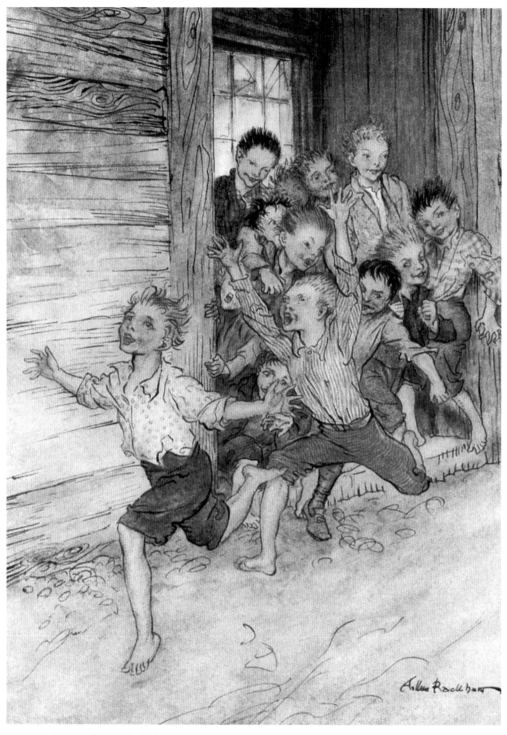

Boys running out of school

Washington Irving, *The Legend of Sleepy Hollow*
• George G. Harrap & Co., London, 1928

Long after *Rip Van Winkle*, Rackham returned to the author Washington Irving, primarily known for these stories from *The Sketch Book*. The outstretched and raised arms of the first two boys are enough to express their joy at leaving school.

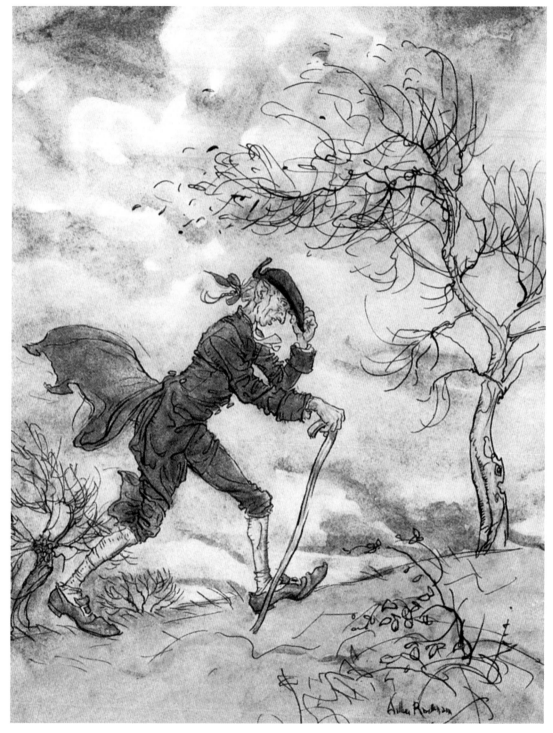

Ichabod Crane

Washington Irving, *The Legend of Sleepy Hollow*
• George G. Harrap & Co., London, 1928

It is unlikely that Rackham identified with any of Ichabod's woes, and would have mocked him as did the story's author. This uncharacteristically bleak country scene and its dying trees is on par with Ichabod's personality.

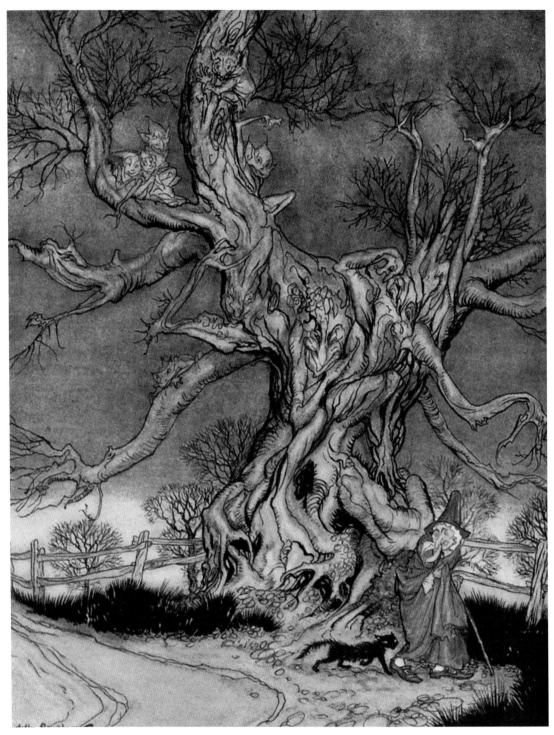

The witch and the black cat

Washington Irving, *The Legend of Sleepy Hollow*
• George G. Harrap & Co., London, 1928

The bleak tree is as ominous a sign as one can imagine coming from Rackham. Whether the artist sensed the gloom of yet another trying illness and social upheaval in his own life is a matter of speculation.

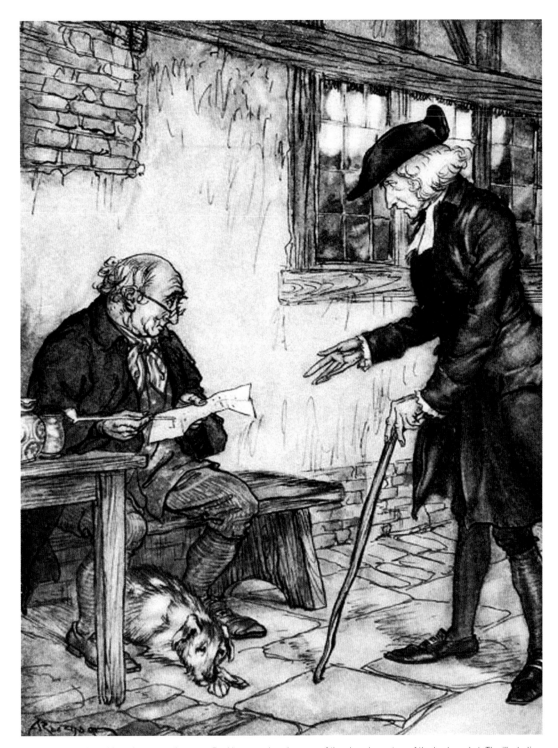

This is the very same rogue who sold us the spectacles
Oliver Goldsmith, *The Vicar of Wakefield*
• George G. Harrap & Co., London, 1929

Rackham was keenly aware of the changing nature of the book market. The illustrations in this book (and the book's narrative) show how Rackham could work outside of fantasy when given the opportunity.

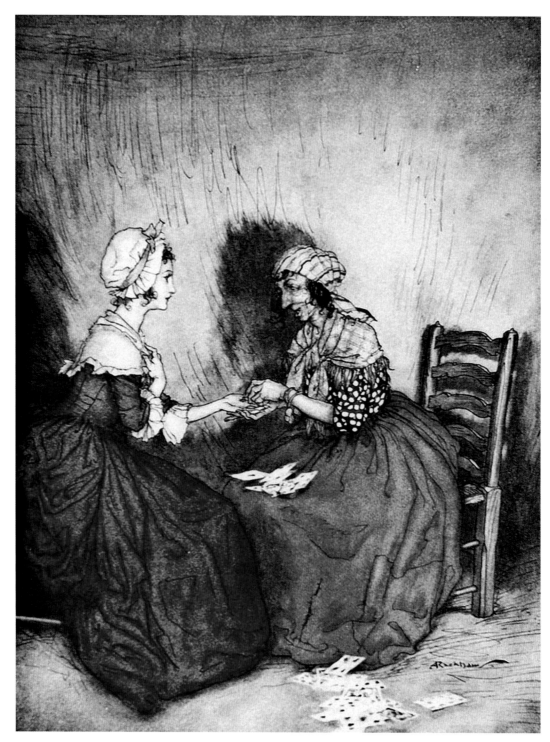

Closeted up with the fortune-teller
Oliver Goldsmith, *The Vicar of Wakefield*
• George G. Harrap & Co., London, 1929

After being 'closeted up' with the fortune-teller for some time, Livy was promised something great. It is easy to see Rackham's daughter Barbara in her character.

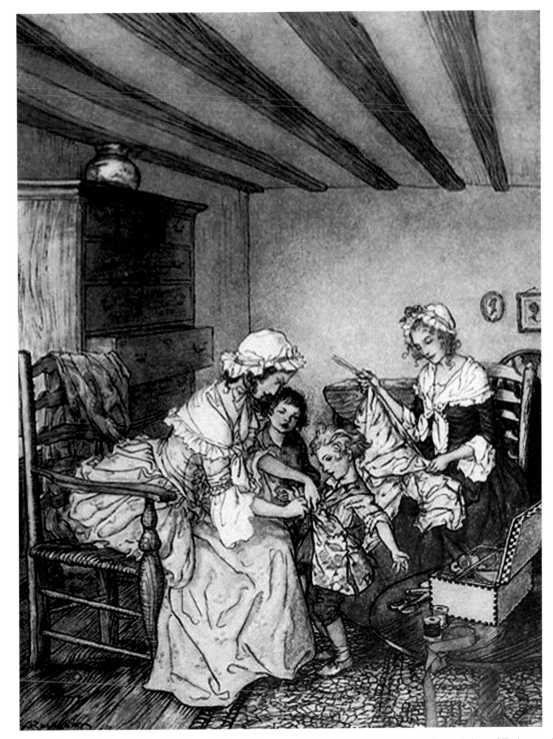

Sunday Waistcoats for Dick and Bill
Oliver Goldsmith, *The Vicar of Wakefield*
• George G. Harrap & Co., London, 1929

Dr Charles Primrose came home to find his daughters cutting up their own frilly dresses with ruffles, to make waistcoats for Dick and Bill. The previous day he had explained to them that finery is unbecoming and he was pleased with the outcome.

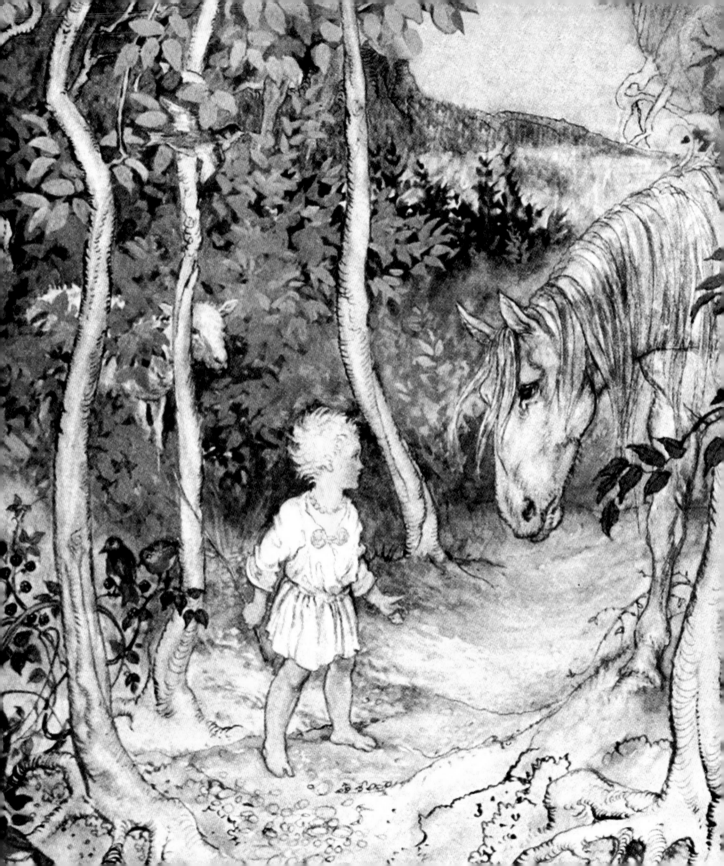

Fairy Tales

Arthur Rackham's use
of watercolours, India ink
and pen make his style
immediately recognizable.
In the period after the
First World War, he also
went on to use silhouette
cuts for some of his fairy
tale illustrations.

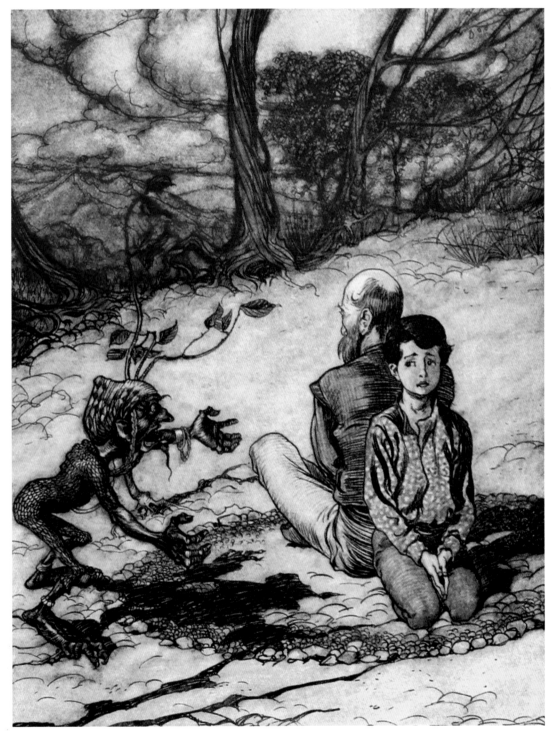

**The Son made a circle, and his Father
and he took their places**
The Fairy Tales of the Brothers Grimm
• Constable & Co., London, 1909

Rackham's second book of Grimm tales was a masterpiece that would bring him great success. His wife Edyth urged him to exhibit the illustrations of the shorter 1900 edition at the Royal Watercolour Society in 1903.

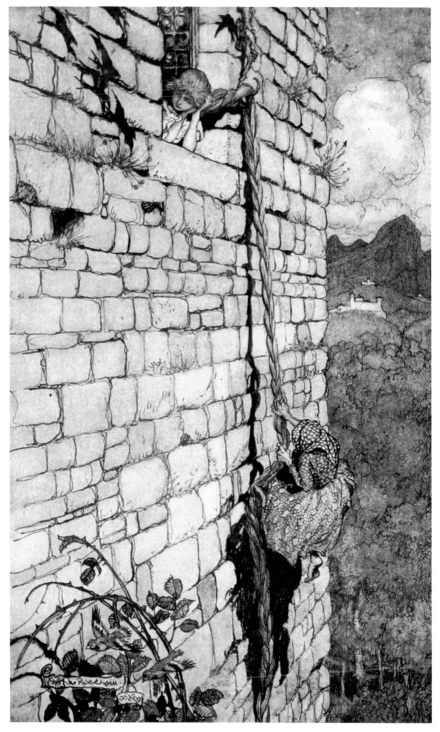

The witch climbed up
The Fairy Tales of the Brothers Grimm,
• Constable & Co., London, 1909

There are few, if any, subjects of fantasy that cannot be found in this collection of tales.
The dominant wall and sheer drop says little of Rapunzel and much about the difficulties
of climbing up such steep heights.

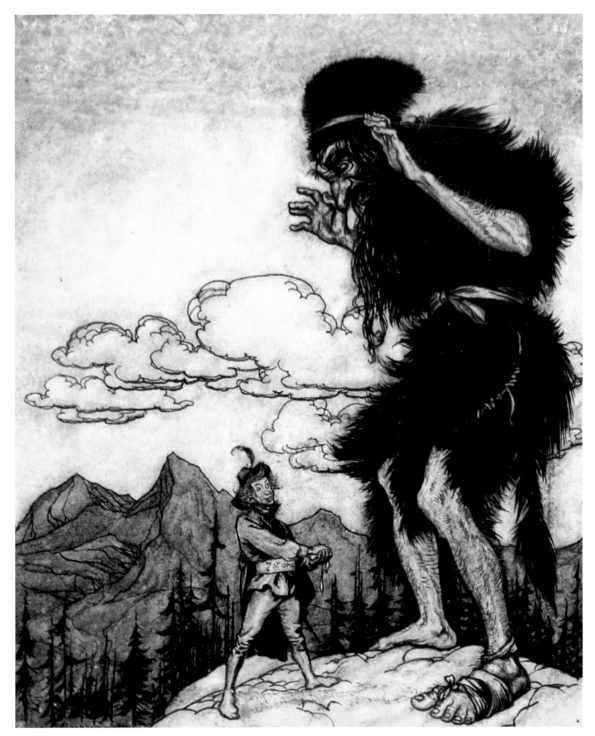

Pulling a piece of soft cheese out of his pocket
The Fairy Tales of the Brothers Grimm
• Constable & Co., London, 1909

Tricking giants, and others, was a game Rackham was no doubt fond of. Playing king was another. The Brothers Grimm offer Rackham more than a few opportunities for trickery and gentle abnegation.

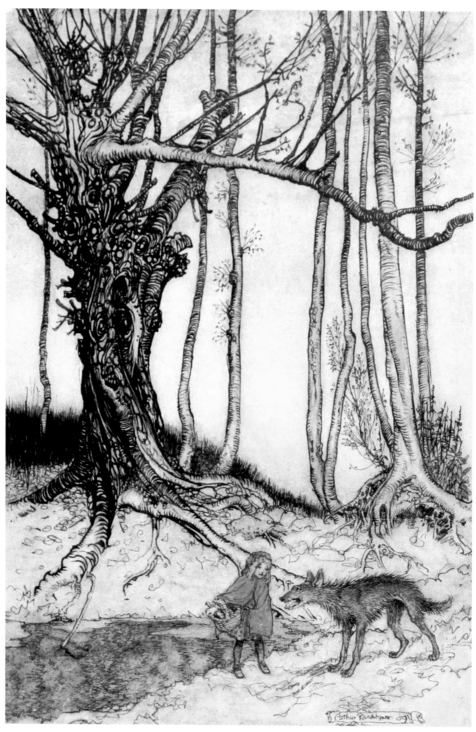

When she got to the wood, she met a wolf
The Fairy Tales of the Brothers Grimm
• Constable & Co., London, 1909

Little Red Riding Hood and the wolf are dwarfed by the stark and bleak surrounding wood. The aloneness of the girl bearing food and comfort to her grandmother is underlined by the emptiness and aridity of the surrounding area.

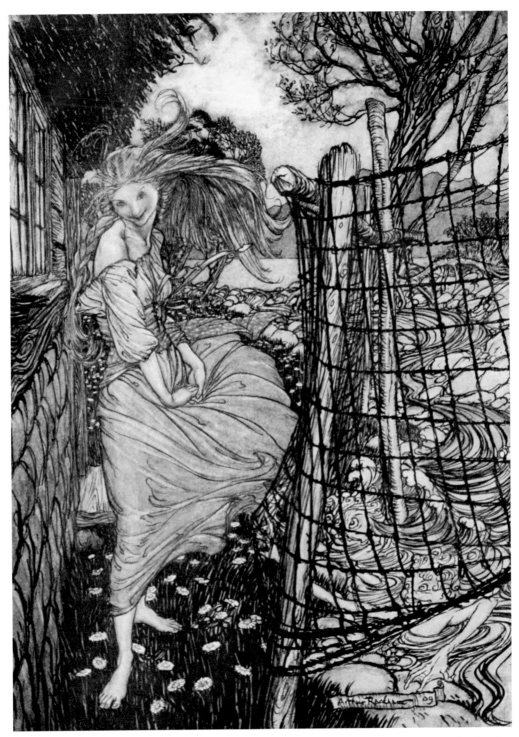

Undine outside the window
De La Motte Fouquè, *Undine*
• Doubleday, Page & Co., New York, 1909

Undine was a water-spirit who had married a Knight and appealed to Rackham in part because of his interest in Germanic folklore and legends, such as has been seen in his treatment of Wagner's 'Ring'.

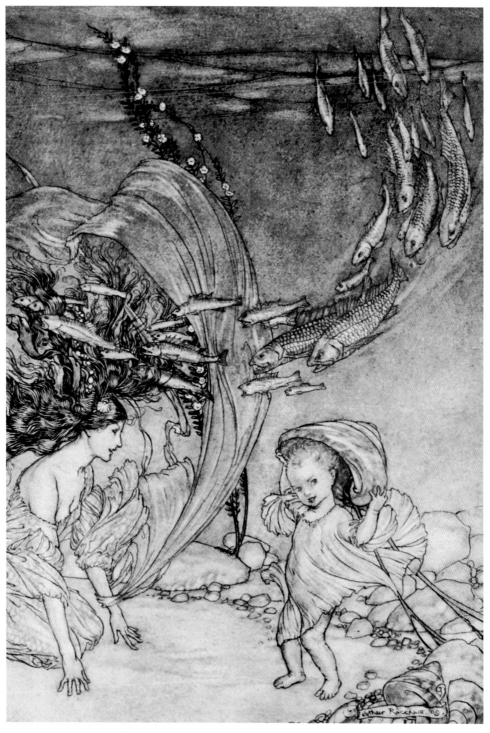

The infancy of Undine

De La Motte Fouquè, *Undine*

• Doubleday, Page & Co., New York, 1909

Rackham was also fond of Naiades and water fairies and spirits. *The Studio* art review in 1909 wrote regarding *Undine* that it was: 'Rackham's singular gift to infuse scholarship with caprice, and also with emotion.'

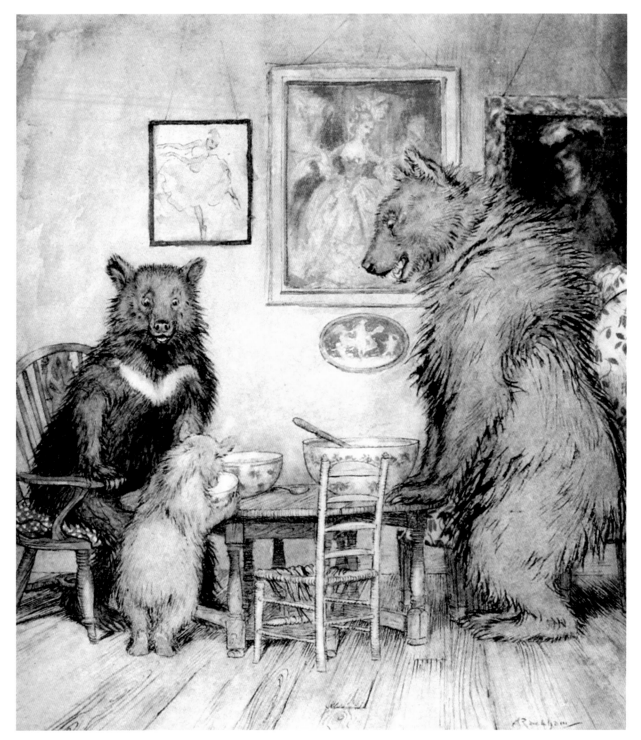

'Somebody has been at my porridge,
and has eaten it all up!'
Flora Annie Steel, *English Fairy Tales*
• Macmillan & Co., London, 1918

Rackham illustrated a copy of his wife's painting, *The Grebe Hat,* on the wall of the sitting room.
The complexity of the composition and its eclectic elements takes the illustration into the realm
of great children's illustration.

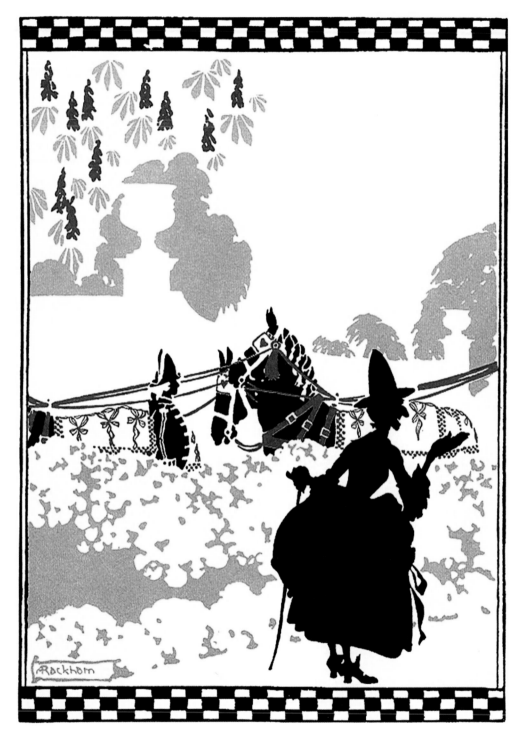

Cinderella promised her godmother that she would not fail to act upon her advice
Cinderella • William Heinemann, London, 1919

Rackham displays his ability to be highly expressive with minimal means. There is also a near abstract quality in his use of colour motifs. The artist manages to reduce two-dimensionality while maintaining merely a slight suggestion of perspective.

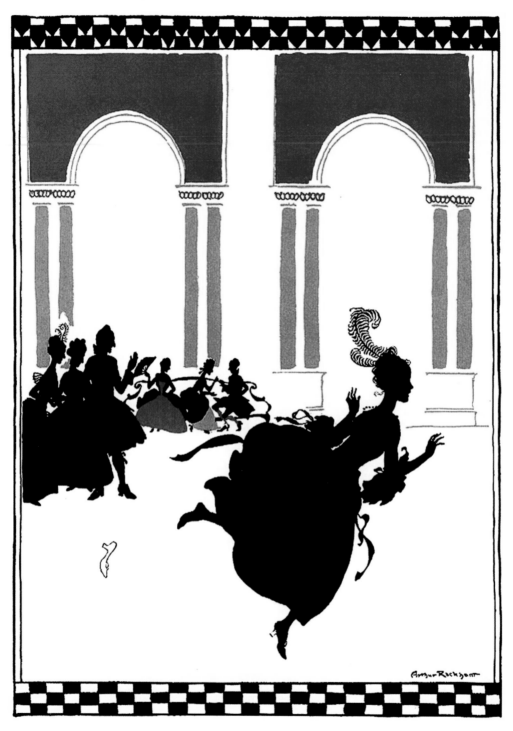

**'You are the lady of my heart,' said he. 'Why are you
so cruel that you will not even tell me your name?'**
Cinderella • William Heinemann, London, 1919

From a seventeenth-century collection of oral folktales first published in Italy as *The Story of Stories* (in Italian), Cinderella in all genres of art, music, and literature is one of the most beloved stories ever told and represented.

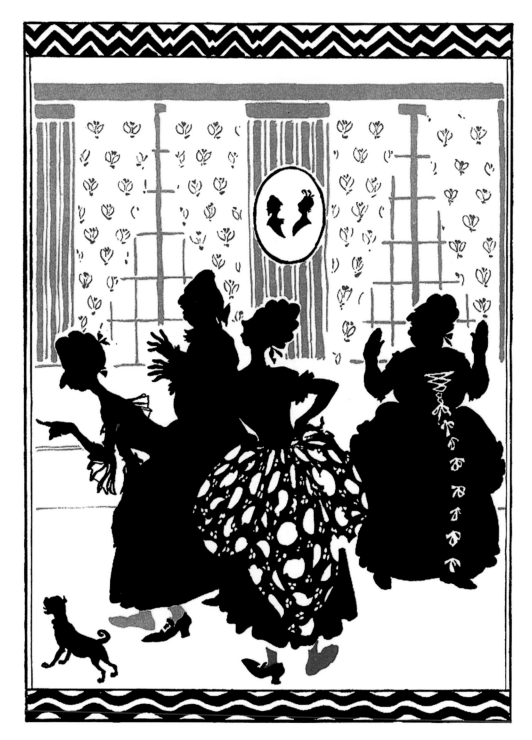

How the sisters stared!

Cinderella • William Heinemann, London, 1919

Rackham was so clearly a master of silhouette illustrations, and this is no exception. The horror can be seen on the sisters' faces when they see that Cinderella's foot fits the glass slipper.

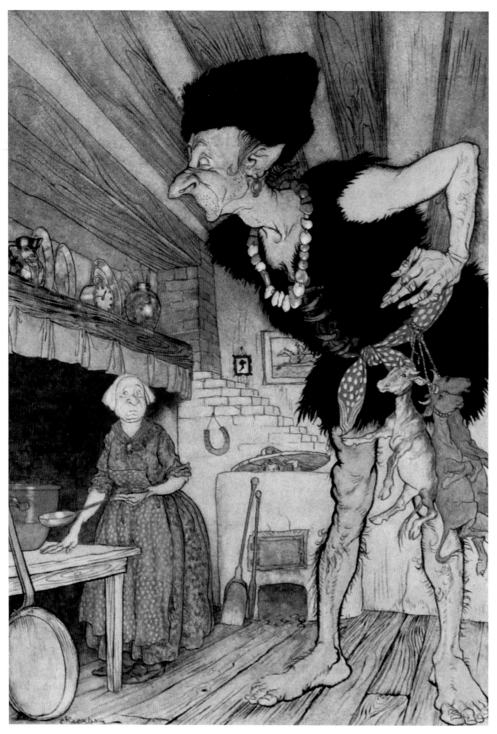

'Fee-fi-fo-fum, I smell the blood of an Englishman'
Flora Annie Steel, *English Fairy Tales*
• Macmillan & Co., London, 1918

After achieving success as an illustrator, Rackham did not particularly care for being labelled and often, like these household tales, he would playfully or gruesomely give free rein to his adult imagination.

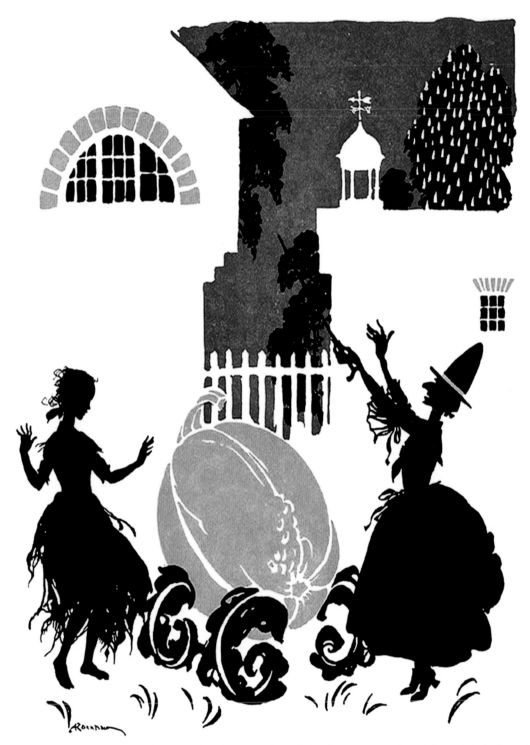

Immediately the coach vanished

Cinderella • William Heinemann, London, 1919

Part of the reason for employing silhouette was to reduce printing costs during the unstable post-war economy. But this did not stop Rackham from using his impressive storytelling skills.

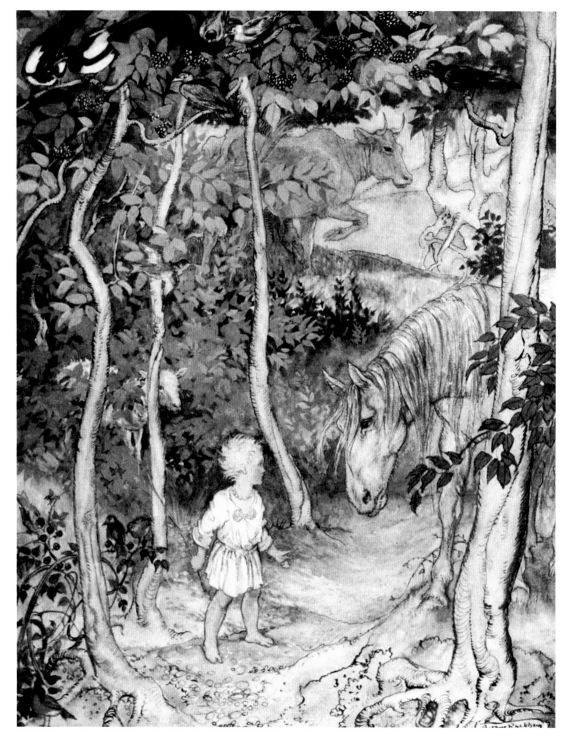

**The horse might stare, all a-cock
with eyes and ears and nose**

James Stephens, *Irish Fairy Tales* • Macmillan and Co., London, 1920

Rackham had his most lucrative year in 1920. In full mastery of his art, in line, colour and composition, this book is enchantingly illustrated and one of the artist's most complex accomplishments in the form.

**Now and again a dog whined in a whisper
and snapped a little snap on the air**
James Stephens, *Irish Fairy Tales* • Macmillan and Co., London, 1920

Rackham must have been aware that he would strike fear in the reader at first sight of this angry pack of dogs. An alternate title to this illustration is, 'They stood outside, filled with savagery and terror.'

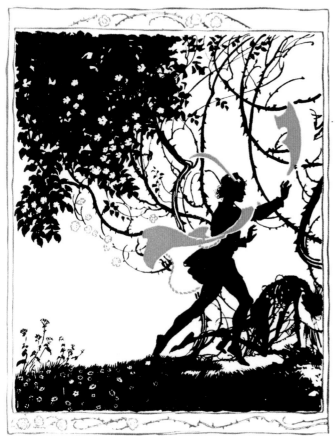
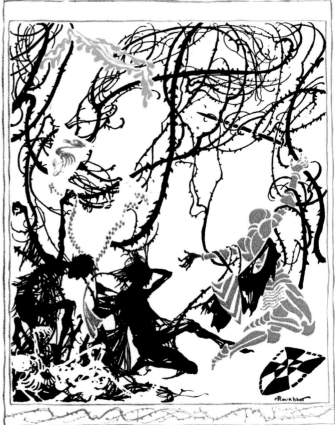

The Prince Fighting Through
C.S. Evans, *The Sleeping Beauty*
• William Heinemann, London, 1920

This was Rackham's second and very popular book in silhouette illustration for Heinemann, a year after *Cinderella*. The freedom of line in this particular image approaches an abstract rendition of dance.

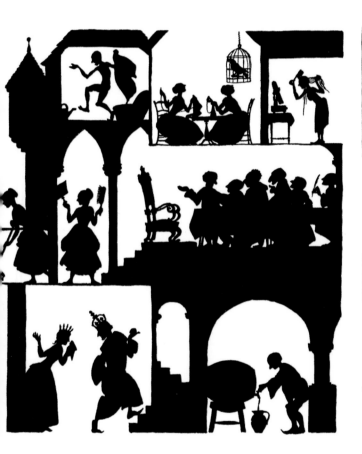
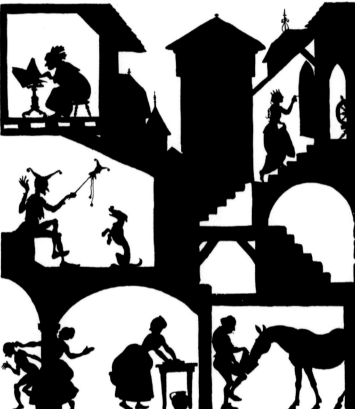

Preparing for the feast
C.S. Evans, *The Sleeping Beauty*
• William Heinemann, London, 1920

Dictated by the form of illustration, Rackham imagines a complex and narrative way to introduce numerous significant elements into the image. One imagines him reading, drawing or playing alone in one of the upper rooms of the bustling castle.

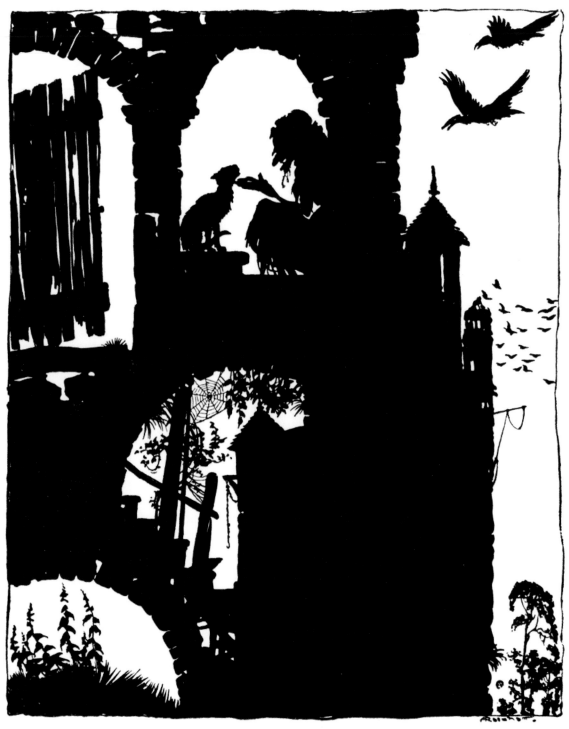

Shut up in the ruined tower
C.S. Evans, *The Sleeping Beauty*
• William Heinemann, London, 1920

Rackham had illustrated *The Sleeping Beauty* several times – including a cancelled version in 1907 and three-color pictures for his *Rackham's Fairy Book* in 1933. Like Cinderella it is one of the most popular stories ever told.

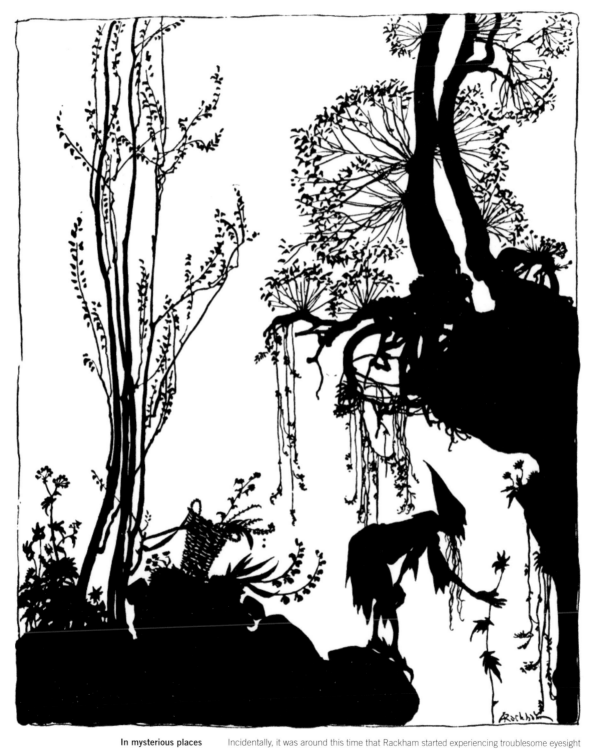

In mysterious places
C.S. Evans, *The Sleeping Beauty*
• William Heinemann, London, 1920

Incidentally, it was around this time that Rackham started experiencing troublesome eyesight problems. Given the minute details in these exquisite black and white silhouettes, however, it is hard to imagine.

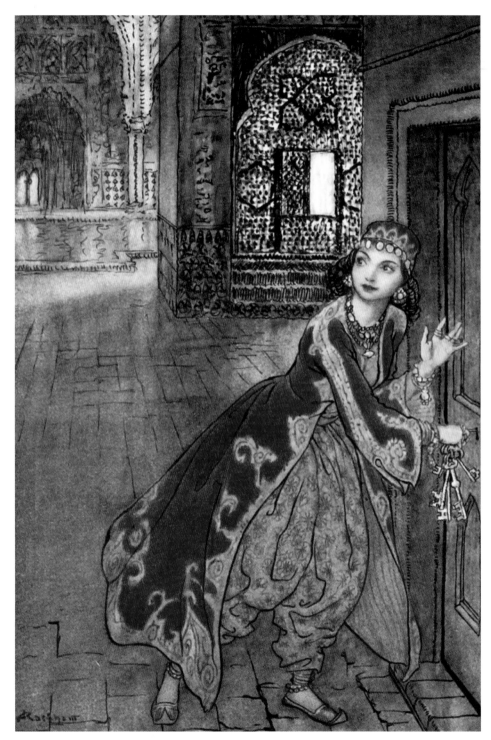

Bluebeard

The Arthur Rackham Fairy Book

• George G. Harrap & Co., London, 1933

Bluebeard is a French folktale most famously told by Charles Perrault. Rackham was likely drawn to it in part because it has long been an adult favourite.

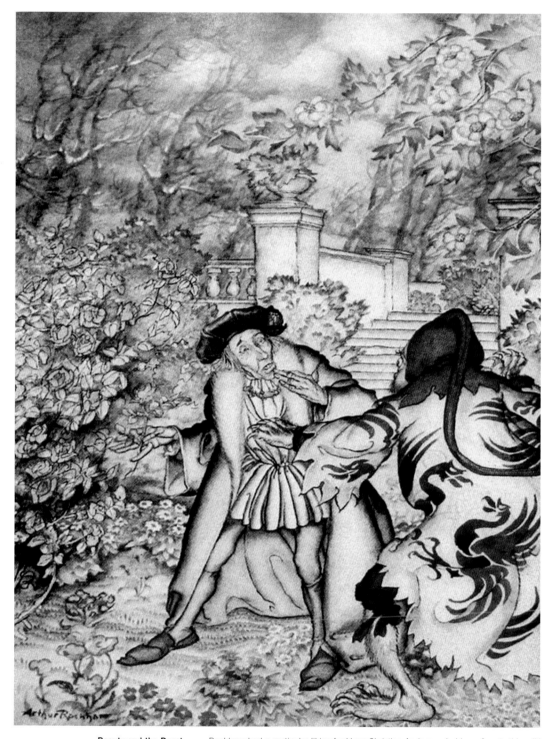

Beauty and the Beast

The Arthur Rackham Fairy Book

• George G. Harrap & Co., London, 1933

Rackham had a particular liking for Hans Christian Andersen. In his preface to this edition, he wrote that Andersen's versions were 'so beautifully told that no one yet wished to improve or edit a single word.'

Indexes

Index of Works

Page numbers in *italics* refer
to illustrations.

General Index

Masterpieces of Art

FLAME TREE PUBLISHING

A new series of carefully curated print and digital books covering the world's greatest art, artists and art movements.

If you enjoyed this book, please sign up for updates, information and offers on further titles in this series at

blog.flametreepublishing.com/art-of-fine-gifts/